# SELECTED WORKS

# THE FINE ARTS MUSEUMS OF SAN FRANCISCO

# SELECTED WORKS

M. H. DE YOUNG MEMORIAL MUSEUM

CALIFORNIA PALACE OF THE LEGION OF HONOR

This publication was made possible by the generous support of The Fairmont Hotels/The Swig Foundations and Grants for the Arts of the San Francisco Hotel Tax Fund.

Produced by the Publications Department, The Fine Arts Museums of San Francisco. Designed by Ed Marquand Book Design, Seattle. Photocomposed by Eclipse Typography, Seattle. Printed by Nissha Printing Co., Ltd., Kyoto, Japan.

Cover: Jean-Baptiste-Camille Corot, *View of Rome: The Bridge and Castel Sant'Angelo with the Cupola of St. Peter's* (detail), 1826–1827. Museum purchase, Archer M. Huntington Fund, 1935.2

Photographers: Joseph McDonald, James Medley, Joseph Schopplein, Kaz Tsuruta

**Library of Congress Cataloging-in-Publication Data**

Fine Arts Museums of San Francisco.
  Selected works.

    1. Art—California—San Francisco—Catalogs.
2. Fine Arts Museums of San Francisco—Catalogs.
I. Title.
N740.3.A59 1987   708.194'61   87-17689
ISBN 0-88401-054-6

# CONTENTS

FOREWORD   7

A HISTORY OF THE MUSEUMS   9

ART OF AFRICA, OCEANIA, AND THE AMERICAS   19

ANCIENT ART   33

EUROPEAN DECORATIVE ARTS AND SCULPTURE   41

EUROPEAN PAINTINGS   67

AMERICAN DECORATIVE ARTS AND SCULPTURE   91

AMERICAN PAINTINGS   107

PRINTS AND DRAWINGS   129

TEXTILES   155

# FOREWORD

The creation of The Fine Arts Museums of San Francisco in 1972 through the merger of the California Palace of the Legion of Honor and the M. H. de Young Memorial Museum led to the consolidation and redistribution of the collections. All French paintings, sculpture, and decorative arts are now in the Legion of Honor in Lincoln Park, making this building modeled after the eighteenth-century Palais de la Légion d'Honneur in Paris the only museum in this country devoted principally to the arts of France. The Achenbach Foundation for Graphic Arts, which functions as the Department of Prints and Drawings, is also located there, as is much of the Museums' collection of European tapestries and porcelains.

The de Young Museum in Golden Gate Park displays art from all other European schools, ancient art, tribal weavings from the Near East and Central Asia, and art from Africa, Oceania, and the Americas. The American Galleries, dedicated to their primary benefactors, Mr. and Mrs. John D. Rockefeller 3rd, are also at the de Young.

This publication offers a brief history of the Museums and a selection of works that represent the scope and quality of the collections. Selections were made by Ian McKibbin White (Director, 1972–1987) working with the curators to choose objects that present the character of the collections as well as their history and their direction for the future. Entries are arranged by collection and were prepared by the curatorial staff. The history of the Museums was compiled by the Publications Department in consultation with members of the curatorial staff and the Public Information Office.

The Fine Arts Museums of San Francisco are enormously grateful to The Fairmont Hotels/The Swig Foundations and to Grants for the Arts of the San Francisco Hotel Tax Fund for their generous support for the publication of *Selected Works*.

Harry S. Parker III
Director of Museums

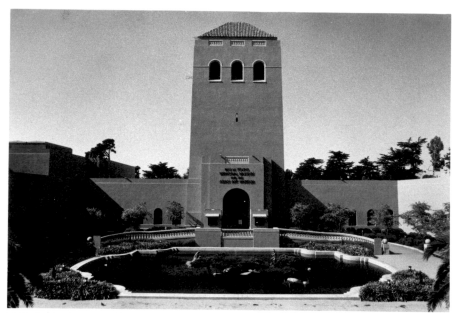

M. H. de Young Memorial Museum

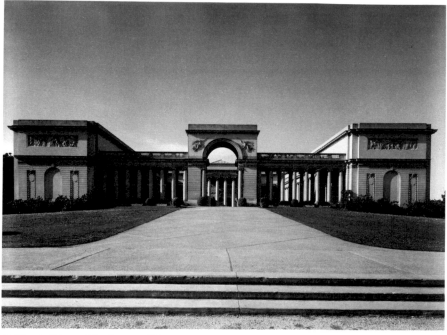

California Palace of the Legion of Honor

# A HISTORY
# OF THE MUSEUMS

The two museums that became The Fine Arts Museums of San Francisco were at one time rival institutions. Nevertheless, they share at least one point of history with each other, as well as with a number of other museums in the United States—each owes its founding to an international exposition. The M. H. de Young Memorial Museum grew out of the California Midwinter International Exposition of 1894, and its original collections reflected the diversity of their origins in the exhibits of both art and artifacts at that fair. The California Palace of the Legion of Honor, founded by Alma de Bretteville Spreckels and her husband, Adolph B. Spreckels, had its genesis in the Panama-Pacific International Exposition of 1915, but it was conceived from the outset as a museum of fine art.

## M. H. de YOUNG MEMORIAL MUSEUM

Because 1893 was a year of financial depression in San Francisco, M. H. de Young, publisher of the *San Francisco Chronicle*, decided that the West was in need of its own world's fair. As National Commissioner at large attending the Columbian Exposition in Chicago in 1893, de Young began to rally public enthusiasm at home. Upon his return he lobbied until the Golden Gate Park Commission granted Concert Valley for the exposition, under the condition that the area be returned to the city in such a state that permanent improvements could be carried out on the land. Only five months after the groundbreaking, the California Midwinter International Exposition opened on 29 January 1894 in Golden Gate Park in San Francisco.

Exhibitors at the fair had been asked to adhere to exotic eastern themes to contrast with the classical themes of the Columbian Exposition and to remind visitors that California, even in January, was another exotic land of sunshine. Over 1,300,000 visitors in five months came to see the buildings laid out on the leveled sand hills of the park. When the fair closed on 4 July, despite the economic depression a profit of $126,991 had been made. The subject of starting a

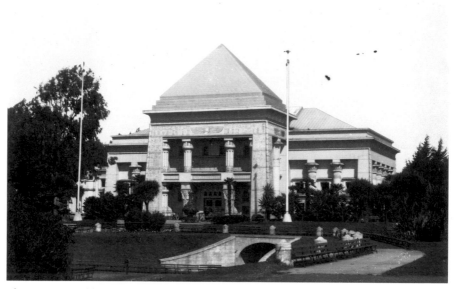

The Fine Arts Building of the California Midwinter
International Exposition, 1894, reopened in 1895 as
the Memorial Museum. Photograph printed from
glass negative, W. C. Billington, photographer.

permanent museum in Golden Gate Park as a memorial to the exposition was
a popular one in the press, so the Executive Committee of the fair, led by M. H.
de Young, offered the Fine Arts building to the Park Commissioners, together
with the surplus funds, for this purpose. After an initial reluctance the commis-
sioners accepted. Thus, the first structure for the Memorial Museum, its link
with an established world of culture from which it was separated by an ocean
and a great continent, was in the Egyptian Revival style, adorned with images
of Hathor the cow goddess.

The new Memorial Museum was a success from its opening 24 March 1895.
No admission was charged, and most of what was on display had been acquired
from the exhibits at the exposition, but de Young immediately began his own
program of acquisitions. When he began acquiring objects for the museum, he
found he had a lot to learn. At Tiffany's in New York he coveted a collection of
antique knives and forks that he described as going back almost to Adam and
Eve. Shocked at their price, he was told that he "didn't understand the museum
game." Upon learning that part of what he was being asked to pay for was the
years and expertise invested in bringing together the individual elements of
the collection, de Young determined he would build his own. During the next
twenty years his taste for the curious, intricate, and ornamental was reflected by
acquisitions of painting and sculpture, arms and armor, fine porcelain, objects
from South Pacific and American Indian cultures, including original art objects
as well as reproductions. Visitors to the museum seem to have shared de Young's

M. H. de Young standing in front of the museum
renamed in his honor in 1921

interest in such diverse objects as sculptures, polished tree slabs, paintings, a
door reputedly from Newgate Prison, birds' eggs, handcuffs and thumbscrews,
as well as two cases de Young had at last filled with a collection of knives and
forks. Six thousand persons viewing the exhibits on a Sunday was considered
not at all out of the ordinary.

Although de Young's interests were admittedly eclectic, it is nevertheless true
that important objects in the Museums' permanent collections were acquired
in the early days of the Memorial Museum's existence. Gustave Doré's *Poème
de la vigne*, known popularly as "The Doré Vase," was acquired from the
exposition and is still exhibited as part of the permanent collection of The
Fine Arts Museums of San Francisco at the California Palace of the Legion of
Honor. The vase stands eleven feet high and twenty-two feet in circumference,
the figures on its surface entwining in grape leaves that cascade down the
swelling sides of six thousand pounds of cast bronze.

Important objects in the collection of ancient art and the art from Africa,
Oceania, and the Americas also entered the museum in these early days, much
of the latter coming from the collection of the museum's first curator, Charles
P. Wilcomb. One of de Young's early acquisitions, John Vanderlyn's painting
*Marius Amidst the Ruins of Carthage*, is the work around which the collection
of American art was subsequently built.

Before long the museum outgrew its buildings. De Young responded by plan-
ning the building that today is familiar to de Young Museum visitors. Louis

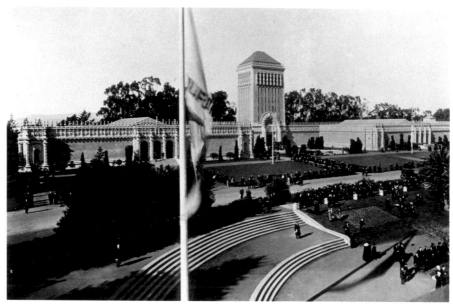

M. H. de Young Memorial Museum, ca. 1925. The
ornamentation deteriorated and was removed in 1949.

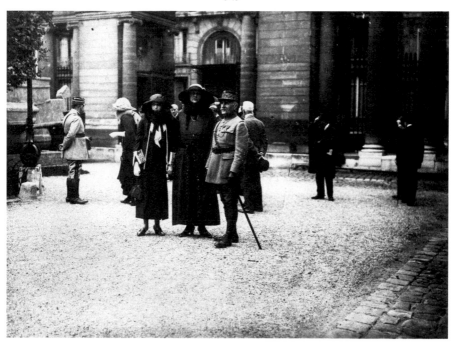

Alma de Bretteville Spreckels and her daughter,
Alma, with Marshal Foch in the courtyard of the
Palais de la Légion d'Honneur in Paris, 1922

Christian Mulgardt, the coordinator for architecture for the 1915 Panama-Pacific Exposition, designed the new Spanish Plateresque-style building that was completed in 1919 and formally transferred by de Young to the city's Park Commissioners. In 1921 de Young added a central section, together with the familiar tower, and the museum began to assume its present configuration. That year M. H. de Young's great efforts were honored when the museum's name was changed to the M. H. de Young Memorial Museum. Yet another addition, a west wing, was completed in 1925, the year de Young died.

The resemblance to the present building was only partial, however, as the museum was encrusted with elaborate cast concrete decorations. The original Egyptian building was declared unsafe and demolished in 1929, and only twenty years later the concrete ornamentation of the de Young was called a hazard and removed, the salt air from the Pacific having rusted the supporting steel. Today a scattering of palm trees offsets the plain stucco facade of the museum that faces the Music Concourse and the California Academy of Sciences.

## CALIFORNIA PALACE OF THE LEGION OF HONOR

The spectacular site of the California Palace of the Legion of Honor commands the attention of visitors even before they enter the museum. Located north of Golden Gate Park, in Lincoln Park, the museum overlooks the Golden Gate and the Pacific Ocean. Legend attributes the selection of the site to Alma Spreckels's friend Loïe Fuller, the flamboyant dancer of art-nouveau Paris who was also a friend of the sculptor Auguste Rodin. It is easy to imagine the dramatic setting inspiring the equally dramatic Miss Fuller to persuade Mrs. Spreckels that the setting was perfect for the museum she had long wished to build. In reality, it is more likely that architect George Applegarth selected the site.

In 1915, Alma Spreckels and her husband, San Francisco sugar magnate Adolph B. Spreckels, visited the French government's pavilion at the Panama-Pacific Exposition. There they viewed an exhibition of sculpture by Auguste Rodin. Mrs. Spreckels had met Rodin the year before, through Loïe Fuller, but she had not yet purchased any of his work. She began her collection by acquiring five pieces from the exposition.

Attending the exposition, Mrs. Spreckels and her husband were impressed as much by the French pavilion as by its contents. It was a replica of the Palais de la Légion d'Honneur, completed in 1788 in Paris originally as the Hôtel de Salm but occupied for only a year by the German prince who built it. Madame de Staël was the owner for a brief time before Napoleon made it the headquarters for his Order of the Legion of Honor. Like another American who had been impressed by the architecture — Thomas Jefferson, who had incorporated the design of its dome into his house, Monticello — Mrs. Spreckels so admired the building that she offered to construct a permanent version of the fair's replica on another site as an art museum.

Mrs. Spreckels was not satisfied that a museum already existed in Golden Gate Park. Given her admiration of the fine arts, she was unlikely to have been

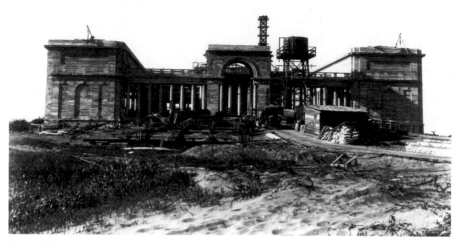

The California Palace of the Legion of Honor
under construction

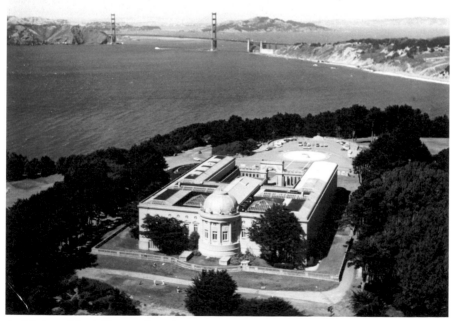

Aerial view of the California Palace of the Legion
of Honor overlooking the Golden Gate

impressed by the randomness of its collections. It was also true that a notori-
ous feud existed between two of the city's leading families, engendered by the
*Chronicle*'s baiting of Adolph Spreckels's father, Claus. After Adolph Spreckels
drew a gun and fired at de Young in the offices of his newspaper, the breach
between the two families did not heal for generations.

Permission from the French government to construct a permanent replica
of its building was granted after the close of the exposition, but World War I
delayed the groundbreaking until 1921. Marshal Foch of France planted a
Monterey cypress near the site to mark the occasion. The new museum was
finished in 1924 under the direction of George Applegarth, a graduate of the
Ecole des Beaux-Arts. Adolph Spreckels did not live to see the completion of
the project; he died in July of that year. On 11 November 1924, Armistice Day,
the museum was given to the City of San Francisco and dedicated to the
memory of California men who fell in the war.

The focus for the collection of the California Palace of the Legion of Honor
was determined at its founding by Mrs. Spreckels's admiration for French and
other European art. She also was instrumental in enlisting the support of other
important patrons. Among the first was Archer M. Huntington, who presented
the Legion with a collection of eighteenth-century French paintings, sculpture,
tapestries, porcelains, and furniture given in memory of his father, Collis P.
Huntington.

The major portion of the museum's paintings collection came from H. K. S.
Williams and his wife, Mildred Anna Williams. They had no heirs and, at Mrs.
Spreckels's suggestion, bequeathed to her museum the contents of their house
in Paris and established an endowment for its future growth.

While she solicited the patronage of others, Mrs. Spreckels placed her own
growing collection of Rodin sculptures in the museum. The Spreckels collection
would eventually number over seventy pieces, many of the forty bronzes having
come directly from Rodin's studio. With the addition of more than thirty orig-
inal plaster casts, the collection remains one of the largest in this country.

In 1948 Mr. and Mrs. Moore S. Achenbach created the Achenbach Foundation
for Graphic Arts and presented their entire collection of prints and drawings to
the City of San Francisco. It was installed first in the main branch of the Public
Library but in 1950 was transferred to the Legion of Honor, and the museum's
collection of works of art on paper, including Mrs. Spreckels's collection of
original designs for Russian ballet sets and costumes, was placed in its care.
Expanded housing for the Achenbach was provided later when a gift from
Hélène Irwin Fagan brought not only additions to the museum's collection
of medieval art, but also funds for remodeling the Legion's galleries and offices.

The museum's founder continued her generosity and in 1955 provided initial
funding and encouragement for the Patrons of Art and Music, a museum auxil-
iary. This organization grew to support the ambitious cultural programs that
Alma Spreckels had envisioned for her museum of fine art; when she died in
1968 her legacy was a museum with a vital future.

## ONE INSTITUTION:
## THE FINE ARTS MUSEUMS OF SAN FRANCISCO

The two museums that had been deeded to the City of San Francisco by their founders had, under the city's administration, shared directors during the thirties, though no official merger took place at that time. The Legion's first official director was Cornelia Bentley Sage Quinton. She was followed in 1930 by Lloyd L. Rollins who, during his three-year tenure, also assumed the directorship of the de Young Museum. Walter Heil came in 1933 and continued the dual directorship until 1939. That year Thomas Carr Howe, who had been an assistant director at the Legion since 1931, became its director, and Heil continued to guide the progress of the de Young until his retirement in 1961.

The de Young's collection remained one of immense variety, even up to the time of the opening in 1931 of a new unit that replaced the demolished Egyptian building. Walter Heil was responsible for the decision to focus the de Young's collecting policies and create a comprehensive museum of fine and decorative art. His predecessor, Lloyd Rollins, had begun to refine the collections; in furthering that process Dr. Heil chose to tactfully refuse personal keepsakes and household bric-a-brac, ending any perception of the de Young as the city's attic.

In the 1950s the de Young received a major gift from the Kress Collection. The de Young was able to acquire such masterworks as *St. Francis Venerating the Crucifix* by El Greco and Pieter de Hooch's *Interior with Mother and Children* as well as choice works by Salomon van Ruysdael, Luca di Tommè, Titian, and an outstanding work by Giovanni Battista Tiepolo, *The Triumph of Flora*.

It was also through Heil that the de Young received a major collection, gifts from Mr. and Mrs. Roscoe F. Oakes of San Francisco that over a period of years filled five galleries, one of them an eighteenth-century period room. Among the paintings in the Oakes collection are such works as Rubens's *Portrait of Rogier Clarisse* and Gabriel Metsu's *Woman Playing a Viola da Gamba*. Hals, Van Dyck, Gainsborough, Reynolds, and Raeburn are also represented. In addition, the Oakeses provided a generous fund for art acquisition that continues to enrich the museums.

When Thomas Carr Howe became director of the Legion of Honor, one of his chief responsibilities was continuing to administer the bequest of paintings and the endowment from Mildred Anna Williams. When Mrs. Williams died in 1939, Mr. Williams insisted that most of the important works go directly to the museum. Europe was then on the brink of war, and over one hundred works came to California from France just before its outbreak.

Howe presided over a long period of thoughtful expansion of the Legion's collections, interrupted only by his service in World War II in the art rescue program (recounted in his *Salt Mines and Castles*, published in 1946). His connoisseurship and diplomacy produced flourishing activity in both purchases and gifts for the museum.

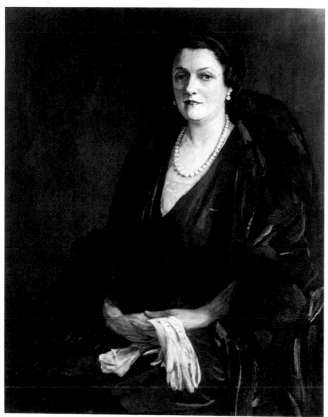

Portrait of Alma de Bretteville Spreckels, by
Sir John Lavery (English, 1856–1941). Oil on
canvas, 46 × 36 in. (116.8 × 91.4 cm). Gift
of Alma de Bretteville Spreckels, 1951.40

Alma de Bretteville Spreckels's death in 1968 marked a turning point in the
history of the two museums. In 1970 their boards of directors agreed that their
common purposes could be achieved more efficiently by one institution, and
that they could thus make greater local and national impact. After a trial period
of two years the merger was ratified in 1972 by a large majority of San Francisco
voters, combining the collections and uniting the two museums under one
board of trustees. Ian McKibbin White, who had been assistant director and,
following Howe's retirement in 1968, director of the Legion of Honor, was
appointed director of the newly formed institution, The Fine Arts Museums
of San Francisco. With the new organization, the California Palace of the Legion
of Honor was designated a museum featuring the arts of France, a decision that
Mrs. Spreckels surely would have endorsed. Other national schools were to be
represented at the M. H. de Young Memorial Museum.

One of Ian White's goals was the establishment of an important center of
American art. In 1973 The Fine Arts Museums became host to the West Coast

Area Center of the Archives of American Art, a bureau of the Smithsonian Institution, now located adjacent to the library in the de Young Museum. Four years later, on 4 July, the American Galleries were inaugurated, and in January 1978 Mr. and Mrs. John D. Rockefeller 3rd announced their intention to give the Museums more than one hundred works from their collection of American art. Much of the collection came to the Museums in 1979, after Mr. Rockefeller's death. Additional support arrived soon afterward when Mrs. Ednah Root offered to fund a curatorial chair in American art.

Another area of the Museums' collections grew impressively when H. McCoy Jones placed in the Museums his collection of more than five hundred rugs, carpets, and embroideries from the Near East and Central Asia. The surprise bequest of Teotihuacán murals from the Harald Wagner Estate enriched the collections of art from Africa, Oceania, and the Americas. In addition, the decorative arts collections have benefited from the generosity of Mr. and Mrs. Robert A. Magowan, and Mrs. Marriner S. Eccles has provided support to the European paintings department.

The creation of The Fine Arts Museums of San Francisco has proven a remarkable success from the standpoint of the reorganization and growth of the collections. Moreover, the outstanding role the Museums have played as both venue and organizer for large traveling exhibitions is also a measure of the stronger international involvement that Ian White fostered during his directorship. At his retirement after twenty years with these museums, the first director of The Fine Arts Museums left a dramatically transformed institution with national and international visibility. His successor, Harry S. Parker III, beginning his tenure as director in July 1987, accepted the responsibility of guiding the Museums toward the extraordinary opportunities created by their recent past.

The Museums now begin a new phase of maturity, continuing to build on the vision of the founders Alma de Bretteville Spreckels and M. H. de Young, who assured that the fine and decorative arts would always have a vital place in the lives of the people of San Francisco.

# ART OF AFRICA,
# OCEANIA, AND
# THE AMERICAS

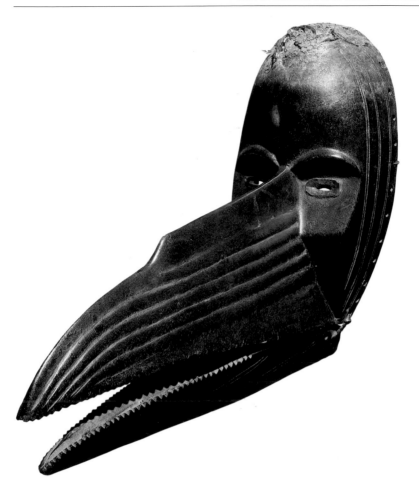

FACE MASK
Mano, Liberia, West Africa, 19th century
Wood, metal, cloth, fiber, and ink;
12¼ × 5½ × 15¼ in. (31.1 × 14 × 38.7 cm)
Gift of The Museum Society Auxiliary
73.9

Among the Mano, masks served as aids in making contact with the spirit
world. They were also used for teaching initiates, settling grievances, main-
taining social control, or simply providing entertainment. This mask repre-
senting a hornbill bird with human features is notable not only for its age
and excellent carving, but also for the Arabic inscriptions of Koranic prayers
(probably dating from the nineteenth century) on the inner surface of the
mask. Pieces of iron have been driven into the forehead, which also is
encrusted with dried blood, feathers, and chewed kola nut. Along the
edge of the mask are three rows of parallel lines and holes through which
a costume was formerly attached.

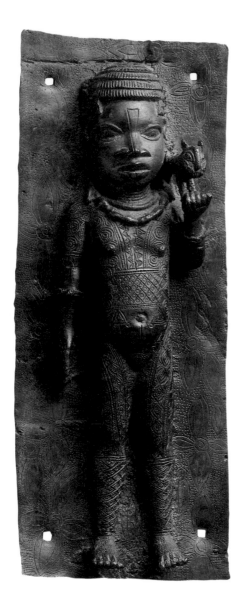

PLAQUE
Benin, Nigeria, West Africa, A.D. 1600
Brass or bronze, 17¾ × 7 in.
(4.5 × 17.8 cm)
William H. Noble Bequest Fund
1980.31

Commemorative in intent, Benin plaques
are thought to depict past rulers and
royal personages of the former Benin
Empire. This outstanding example,
unique in that it is the only known repre-
sentation of a female on a rectangular
Benin plaque, depicts a standing nude
girl carrying a young leopard on her
left shoulder. The leopard is a royal
emblem of kingly power and here may
be represented in the form of a ritual
water vessel. The plaque is pierced at
the four corners so that it could be
attached to the wooden pillars of the
royal palace in ancient Benin City.

NAIL AND BLADE OATH-TAKING
IMAGE (*NKISI N'KONDI*)
Kongo, coastal Zaire, 19th century
Wood, textile, iron, bronze, twigs, glass,
and horn; 32½ × 12 in. (82.5 × 30.5 cm)
Museum purchase, gift of
Mrs. Paul L. Wattis and
The Fine Arts Museums Foundation
1986.16.1

The acute alertness of this figure's pose
indicates its central role in settling law-
suits or serious disputes. Viewed as a
living presence, the object is conversed
with by clients, each nail or blade driven
into the wood symbolizing the words
and oaths that resolved a legal matter.

   Collected in 1903 by R. Visser, the
ethnographer and collector of Belgian
Congo material, this piece is extremely
important historically.

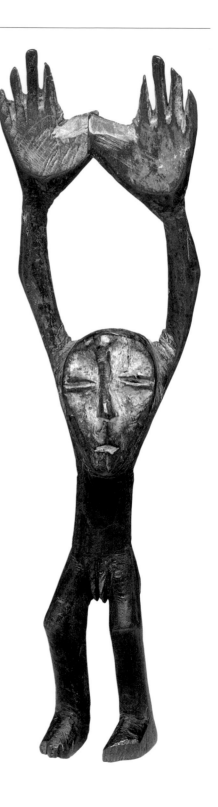

FIGURE (*KASUNGALALA*)
Lega, eastern Zaire, 19th century
Wood and kaolin, 12 × 3¼ in.
(30.5 × 9.5 cm)
Museum purchase, gift of
Mrs. Paul L. Wattis and
The Fine Arts Museums Foundation
1986.16.5

This figure has long been considered one
of the masterieces of African art. The
outstretched arms, a unique feature,
symbolize the supreme arbiter. The
gesture gives a monumental quality to
this relatively small object, which would
have been individually owned by ini-
tiates of the highest grade within the
Bwami association.

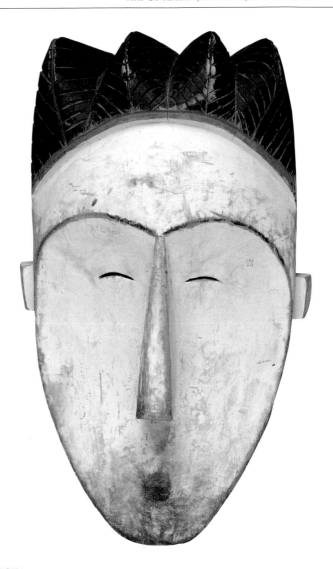

HELMET MASK (*NGIL*)
Fang, Ogowe River, Gabon, collected before 1900
Wood and paint, 19½ × 11 in. (49.5 × 28 cm)
Gift of Mr. Siegfried Aram
X71.7

Characterized by a concave, heart-shaped face, this elegant mask was made
by the Fang people who live along the Ogowe River in Gabon. Stylized hair
crowns the elongated face which is painted with white kaolin. The mask was
worn during the initiation of members into the *ngil* society, an organization
whose chief purpose was to police the village and to maintain social order.
This type of mask was often edged with raffia.

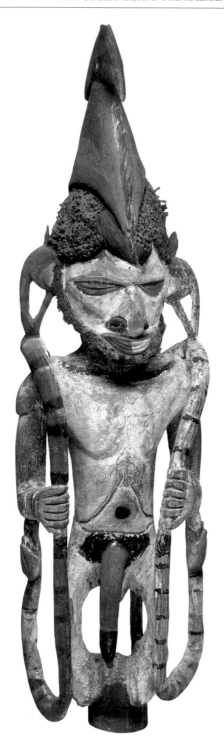

FIGURE (*TOTOK*)
New Ireland, Melanesia, 19th century
Wood, pigment, fiber, and twigs;
30¾ × 8½ in. (78.1 × 21.6 cm)
Museum purchase, gift of
Mrs. Paul L. Wattis and
The Fine Arts Museums Foundation
1986.16.2

Memorial carvings such as this one are
used in complex ritual cycles that take
years to complete. They celebrate ances-
tral propitiation and initiation as well as
funerary rites. This rare figure is unique
for its closed eyes, which give it an
inward, brooding quality.

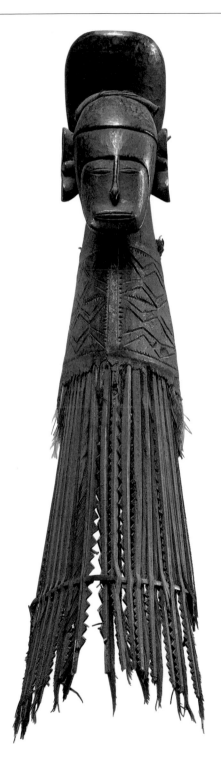

WAR CHARM
Mantankor, Admiralty Islands,
Melanesia, 19th century
Wood, cane, parinari nut paste,
and frigate bird pinfeathers;
16 × 4 in. (40.6 × 10.2 cm)
William H. Noble Bequest Fund
1979.24

Collected in the 1800s, this war charm
is an outstanding example of the type of
ornament worn by warriors. At one time
used throughout the islands belonging
to the Admiralty group, such ornaments
were secured around the neck to hang
down the back of a warrior. These
charms were highly prized personal
possessions thought to bring protection
from wounds and harmful spirits dur-
ing warfare. The head on this example
may represent a legendary ancestor.

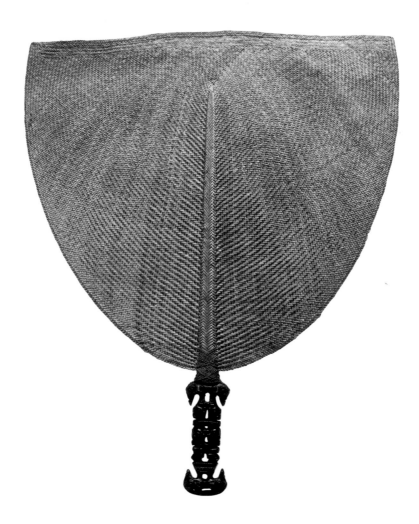

CEREMONIAL FAN
Marquesas Islands, Polynesia, 19th century
Wood and coconut-leaf fiber, 11¾ × 13½ in. (42.5 × 34.3 cm)
Museum purchase, gift of Mrs. Paul L. Wattis
and The Fine Arts Museums Foundation
1984.12

The Marquesas Islands were a primary art-producing area where a special
class of professional artists existed. This fan is representative of the prestige
objects made by these artists and frequently used in ceremonies by chiefs
and chiefesses. The precisely carved handle with paired tiki figures and
birds/lizards, along with the finely executed plaiting of the fan, show
Polynesian craftsmanship at its best.

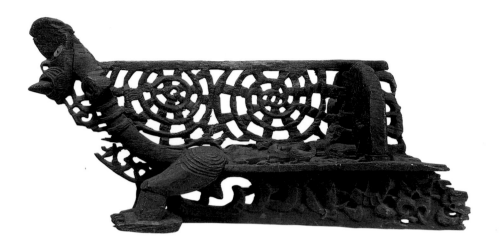

CANOE PROW (*TAUIHU*)
Maori, New Zealand, 19th century
Wood and shell, 22¼ × 46 in.
(56.5 × 116.8 cm)
California Midwinter International
Exposition
5524

Carving was a sacred profession among the Maori, carried on through the centuries by a succession of master woodcarvers who occupied an intermediate status between gods and man. Ritual incantations, purifications, and strict ceremonial procedures accompanied virtually every step of the carving process, from felling a tree to setting the finished pieces in place. Craftsmanship was highly valued, and fine carvings were a matter of tribal pride and prestige.

Figureheads, or *tauihu*, were lashed to the front of Maori war canoes. This extraordinary example was carved in the East Coast style of the Ngati Porou people. The crouching figure at the front with its fiercely protruding tongue and identifying tattoo markings served to frighten the enemy in battle. Although weathered, the piece reveals the intricate design and masterful skill of the artist who created it.

Such great care was taken to keep the wood from splitting that the delicate carving process for these pieces might take as long as two generations to complete. The figureheads were highly prized, and after a canoe was no longer useful the prow would be removed and attached to a new vessel.

## SERPENTINE MASK
Olmec, Xochipala, Guerrero, Mexico,
1200–800 B.C.
Serpentine, 6¼ × 6 in. (15.9 × 15.2 cm)
Museum purchase, Salinger Bequest Fund
72.43

An Olmec deity or artistocrat may be
portrayed by this exquisite work, finely
carved from serpentine, one of the sacred
green stones of the Olmec. The face dis-
plays characteristic features associated
with the were-jaguar, a mythical half-
human, half-feline being, characterized
by a downturned mouth with a flared
upper lip, puffy cheeks, and almond
eyes. On the left side of the mask and
extending down the cheek is an incised
carving of a human profile, also with
were-jaguar traits. The holes in the eyes,
nostrils, and sides indicate that the
mask may have been worn for brief
periods.

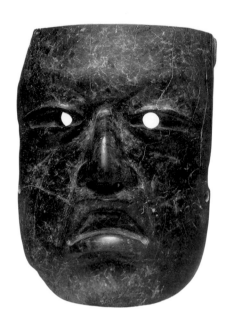

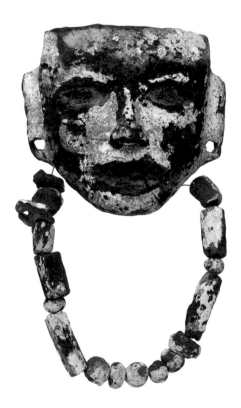

## BURIAL MASK WITH NECKLACE
Teotihuacán, Mexico, A.D. 300
Wood, pigment, and stucco;
mask 3 × 4 in. (7.6 × 10.2 cm),
necklace diam. 9 in. (22.9 cm)
Mrs. Paul L. Wattis Fund
1980.38 a–b

The art style of Teotihuacán, revealed in
mural paintings, sculpture, architecture,
and pottery is refined and elegant, marked
by an austerity that is often present
in burial masks. This mask with neck-
lace, found in a cave in Guerrero, is
unique in that it is the only one known
from the Teotihuacán civilization to be
carved in wood. Most masks were made
of greenstone, jadeite, or other types of
stone. This example possibly represents
a deity and could have been placed over
the face of a dignitary in burial. Vestiges
of paint remain on the surface; origin-
ally there were probably stepped yellow
and blue patterns on the cheeks. The
eyes were of pyrite which has disinte-
grated over time.

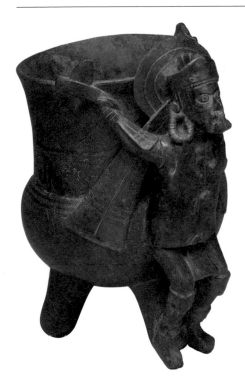

WARRIOR VESSEL
Mixtec, Guerrero or Oaxaca, Mexico,
A.D. 1200 – 1300
Ceramic and paint, 10½ × 6½ × 8¼ in.
(26.6 × 16.5 × 21 cm)
Mrs. Paul L. Wattis Fund
1979.6

Undoubtedly an offering for a very im-
portant tomb, this splendidly detailed
vessel shows a blend of Mixtec and Aztec
styles. The highly ornamented figure may
represent Tlaloc, the ancient rain god,
identified by the fangs that protrude from
his mouth. The piece may have come
from a tomb located on the coast of
Guerrero or Oaxaca and is an example
of a type of pottery usually found only
in broken fragments, so its intact state
is exceptional.

EFFIGY JAR
Moche, North Central Peru,
400 B.C. – A.D. 600
Ceramic, 7¼ × 4½ in. (18.4 × 11.4 cm)
Estate of Henry J. Crocker
61.1.9

The Moche civilization which flourished
along northern Peru was noted for fine
thin-walled pottery of the highest quality.
Outstanding among Moche ceramics were
the stirrup-spout vessels, often modeled
with figures characterized by a remark-
able degree of naturalism and expression.
The artists chose scenes and characters
from everyday life. This beautifully
painted kneeling warrior appears to be
a portrait of a specific soldier in military
attire, including a conical hat, a shield,
and a club. These vessels were probably
made as offerings and used for ritual
purposes.

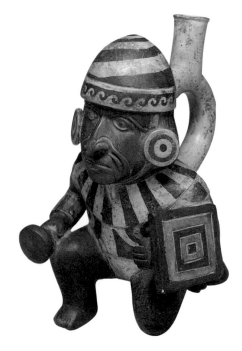

TETRAPOD VESSEL WITH COVER
Maya, Northern Petén, Guatemala, A.D. 280
Ceramic, stucco, and paint; H. 12 in.
(30.5 cm), diam. 33 in. (83.5 cm)
William H. Noble Bequest Fund
1979.55

This lidded vessel, originally covered
entirely with stucco and painted, was
a tomb offering that would have been
buried with an aristocratic individual.
The figure on the lid appears to be a
Muscovy duck with a fish in its mouth,
both creatures symbolizing the precious-
ness of water in the lives of the Guate-
mala lowland Maya. The wings of the duck
bear incised serpent faces, and the four
legs supporting the vessel contain pellets
that rattle when the vessel is shaken.

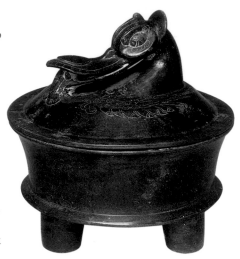

LIDDED JAGUAR VESSEL
Maya, Northern Petén, Guatemala,
3rd century A.D.
Ceramic and paint, H. 9½ in. (24.1 cm)
Gift of Mrs. Paul L. Wattis, William H.
Noble Bequest Fund, AOA Acquisitions
Fund, and C. Barry Randell Bequest Fund
1982.42

Lidded effigy vessels of humans or
animals were produced during a very
limited time in the highland and lowland
areas of Guatemala. Few examples of this
type of pottery are in existence; at least
one was found buried with offerings of
copal inside. The jaguar is the preemi-
nent symbol of Maya royal power and
authority, and spotted jaguars figure
prominently on painted vases of later

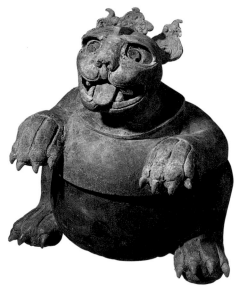

periods. This superb example shows
a crouching jaguar with open mouth
displaying teeth and tongue, a neck-
lace or mantle, and decorated ears or
headpieces.

# ANCIENT ART

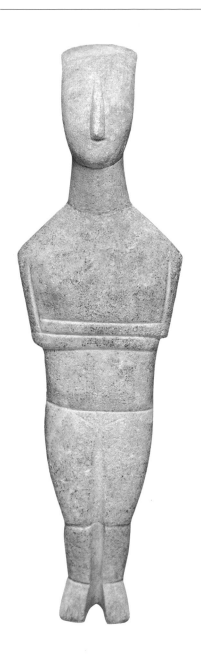

CYCLADIC FIGURE
Goulandris Master
Greek, the Cyclades, Early Cycladic II,
ca. 2500 B.C.
Marble, H. 13⅛ in. (33.4 cm)
Museum purchase, William H. Noble
Bequest Fund
1981.42

Of all the creations made by the inhabi-
tants of the Cycladic Islands in the third
millennium B.C., the marble figures are
the most important and the most enig-
matic. The simplicity of form and contour
and the balanced proportions convey a
strikingly modern impression. Although
most excavated figures come from graves,
it is not at all certain that they were
made exclusively as funerary objects.

This delicately shaped figure is a
fine example of the early work of the
Goulandris Master, a prolific Cycladic
artist whose sculptural repertoire includes
the use of a long, semi-conical nose on a
lyre-shaped face, markedly sloping shoul-
ders, a rounded back, and neatly incised
details.

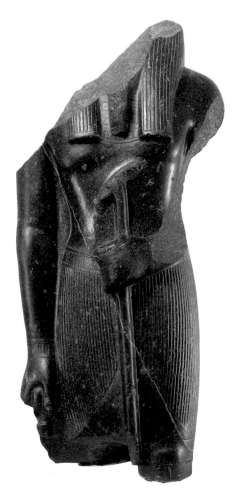

DEITY
Egyptian, New Kingdom, 18th Dynasty, ca. 1363–1353 B.C.
Diorite, 38 × 18½ × 13¼ in. (96.5 × 47 × 33.7 cm)
Museum purchase, M. H. de Young Endowment Fund
54661

Dating from the zenith of Egyptian art and civilization, this life-sized torso
has been associated with the reign of the pharaoh Amenhotep III (1391–
1353 B.C.) and may have been commissioned for his royal jubilee. Three
such events, called *Sed*-festivals, intended to rejuvenate the failing powers
of the aging ruler and emphasize his relationship with the gods, were held
during the last decade of his reign.

The god wears a pleated linen kilt and carries in his right hand the *ankh*,
a symbol of life. In his left he holds the *was* scepter, representing happiness
and welfare. The loss of the head and the absence of an inscription make
it impossible to identify the figure.

PLAQUES FROM NIMRUD
Assyrian, 8th century B.C.
Ivory, u.l. 3⁷/₁₆ × 2⅜ in. (8.7 × 6 cm), u.r. 2¼ × 2½ in. (5.7 × 6.3 cm),
l.l. 4³/₁₆ × 1¾ in. (10.7 × 4.4 cm), l.r. 3⅛ × 2¹¹/₁₆ in. (7.9 × 6.8 cm),
c. 4¾ × 3¾ in. (12 × 9.6 cm)
From the British School of Archaeology in Iraq,
William H. Noble Bequest Fund
1980.54.1 – 5

Excavations that began in the mid-nineteenth century at the Assyrian
capital of Nimrud have brought to light the largest and finest collection
of carved ivories known from the ancient world.

   Our selection of Nimrud ivories represents a cross-section of international
motifs common in the early first millennium B.C. and reflects the cultures of
the Near East and the Mediterranean basin. Despite the plaques having been
found in an Assyrian city, neither the design nor the craftsmanship are
Assyrian. The Syro-Phoenician artists who carved these plaques borrowed
heavily from Egyptian art that portrayed youths binding lotus and papyrus
plants, fantastic composite animals in equally fantastic floral settings, and
winged humans flanking a central plant. These highly prized luxury pieces
were applied as inlays that decorated the furniture of the Assyrian court.

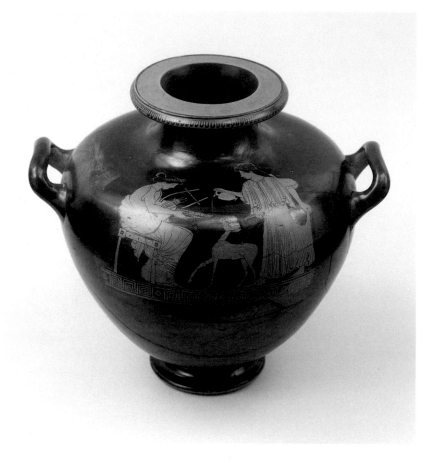

RED-FIGURE HYDRIA
Attributed to the Pan Painter
Greek, Athens, ca. 460 B.C.
Terracotta, H. 10$^{13}$/16 in. (27.5 cm),
diam. with handles 11$^{3}$/16 in. (28.5 cm)
Gift of the Midwinter Fair Commission
707

This hydria, a pot for water, has been attributed to the Pan Painter, an Early
Classical artist still working in the archaizing style of his predecessors. The
hydria, one of the most beautiful of all the Greek vase shapes, was also one
of the most difficult to decorate. This gifted artist has arranged the place-
ment of the figures so that they accentuate the continuously curving surface.
The elegantly rendered scene depicts the seated god Apollo holding a lyre.
He accepts the wine poured by his sister Artemis, while his attentive fawn
watches for any mispoured drops. This mythological scene of gods serving
wine to each other was popular among the Athenian vase painters.

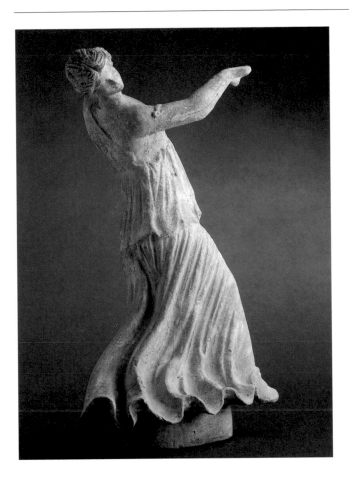

DANCING WOMAN
South Italian, Centuripe, Sicily, 2nd century B.C.
Molded terracotta with traces of polychrome,
17½ × 9½ × 4¾ in. (44.5 × 24.2 × 12.1 cm)
Museum purchase, Salinger Fund
78.4

Although the Greek colonies of Magna Graecia, such as Centuripe in Sicily, remained politically independent of mainland Greece in the second century B.C., artistically they followed directions established by the motherland. This dancing woman represents the merging of the sober tradition of clay figures developed in Greece with the inspiration of newer, more dramatic figures from Asia Minor. Her swirling draperies and elaborate gestures are characteristic of the livelier, freer poses favored in this period.

Terracotta figures such as these were usually cast from molds, and details were added with a pointed tool. After firing they were painted bright colors. The precise function of the figures is not known, but they were probably votive offerings at tombs or domestic shrines.

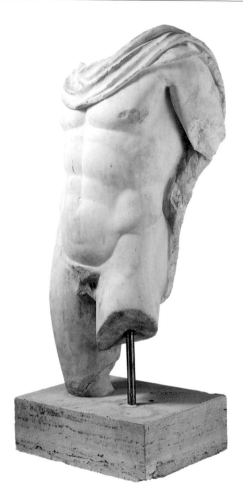

TORSO OF HERMES
Roman, 2nd century A.D. after Greek original, 5th century B.C.
Pentelic marble, H. 38³⁄16 in. (97 cm)
Gift of Vincent Price
1986.26

This exceptionally fine Roman torso, greater than life-size, is derived from
the earlier Greek statue by the classical artist Polykleitos (490–425 B.C.).
Polykleitos was the first Greek sculptor to emphasize the muscular body
of the athlete, establishing the canon for the proportions of the male body
that was greatly admired and often imitated by the ancient sculptors.

Apparently a rare copy of his statue of Hermes, this torso shows the god
standing in an attitude favored by Polykleitos, with the weight resting on
the right leg, the left leg flexed. The clear demarcation of the planes of the
body and the harmonious symmetry of the design were hallmarks of this
great artist's style.

# EUROPEAN DECORATIVE ARTS AND SCULPTURE

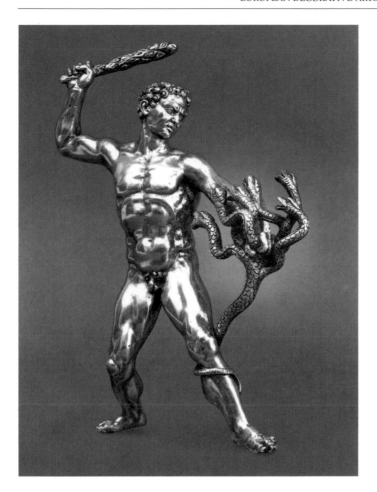

CIRCLE OF ANTICO
North Italian, Mantua
*Hercules Slaying the Lernaean
Hydra*, ca. 1520
Silver, H. 8½ in. (21.5 cm)
Gift of John Goelet in tribute
to Whitney Warren
1985.27

Figures that were cast rather than
hammered from precious metals are of
extreme rarity today, even though early
sources tell us they were abundant dur-
ing the Renaissance. Many sculptors at
this time trained first as goldsmiths and
continued to produce prized cabinet
pieces such as this *Hercules*.

The choice of material, like the sub-
ject, reflects a particular taste for antiq-
uity that flourished in northern Italy.
The subject represents the second labor
of Hercules, who slew the nine-headed
monster. Each time he severed one head,
two more would grow in its place. The
composition was used by Antico in one
of a series of bronze reliefs made ca. 1496
for the Gonzagas in Mantua. Both are
probably based on a common ancient
sarcophagus. The style of the figure's
hair and facial features, reminiscent of
figures in Mantegna's engraved *Battle of
the Sea Gods* (ca. 1485–1488), likewise
suggests a Mantuan origin.

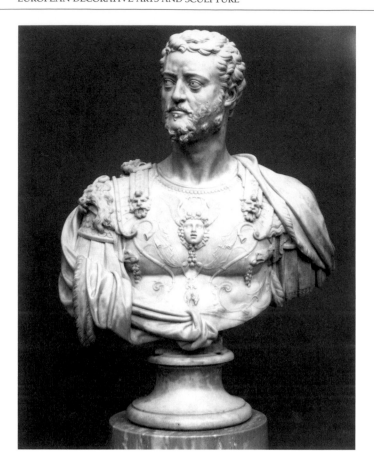

WORKSHOP OF BENVENUTO CELLINI
Italian, Florence, 1500–1571
*Portrait Bust of Cosimo I de' Medici,*
*Grand Duke of Tuscany,* ca. 1548–1583
Marble, H. 30 in. (76.2 cm)
Roscoe and Margaret Oakes Collection
75.2. 16

In 1547 Cellini completed a bronze portrait of Cosimo de' Medici (Florence,
Bargello), which must have originally been partially gilt and had silvered
eyes in the antique fashion. It was not exhibited for ten years. Cellini began
making this marble copy, slightly reduced in size, probably from a working
model for the bronze. A document of 1548 states that the artist purchased
the marble for this piece and a companion portrait of the Grand Duchess
Eleonora of Toledo (now lost). Both of these busts were in Cellini's studio
at his death in 1571. However, the soft style of the carving suggests
the Museums' work was probably completed by Cellini's assistant,
Antonio Lorenzi.

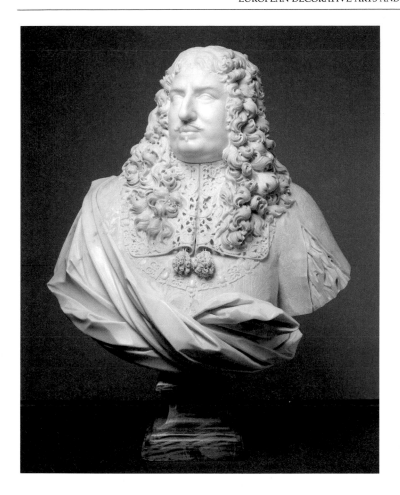

LORENZO OTTONI
Italian, Rome, 1648–1736
*Portrait Bust of Maffeo Barberini, Prince of Palestrina,* 1685–1687
Marble, H. 29½ in. (75 cm)
Museum purchase, Roscoe and Margaret Oakes Income Fund
1984.80

Ottoni's portrait of Maffeo Barberini is an outstanding example of the
virtuoso carving of late baroque sculptors in Rome, who drew heavily on
the dynamic effects of Bernini as well as on the noble classicism of Algardi.

This bust is part of a series of portraits of the cardinals and princes of
one of the most powerful families of seventeenth-century Rome. The series
was commissioned to Lorenzo Ottoni by Maffeo's brother, Carlo Barberini,
in 1685–1687. The portrait was sculpted posthumously, after a painting
by Carlo Maratta. The terracotta model for the bust is still owned by the
Barberini family.

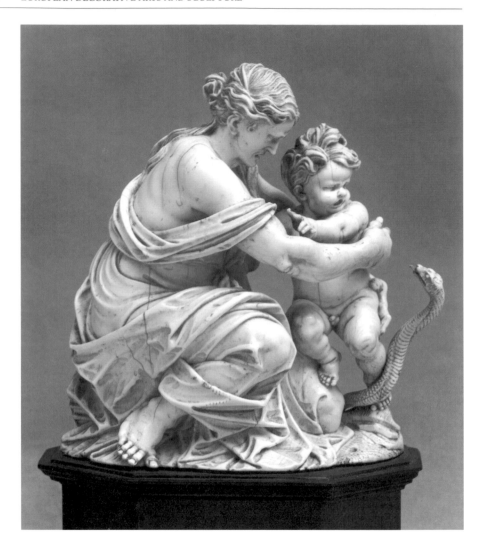

ATTRIBUTED TO GERARD VAN OPSTAL
Franco-Flemish, 1597–1668
*Infant Hercules and the Serpent*, mid-17th century
Ivory, H. 6 in. (15.2 cm)
Gift of The de Young Museum Society
52.6.4

Born in Brussels, van Opstal worked initially in Antwerp but became
a French citizen between 1645 and 1651 after going to Paris to work for
Cardinal Richelieu on many projects for Louis XIV, including those at the
Louvre and the Tuileries. Van Opstal was one of a number of artists who
brought the style of Rubens to Paris. His surviving work is known mainly
through ivory reliefs with Bacchic subjects.

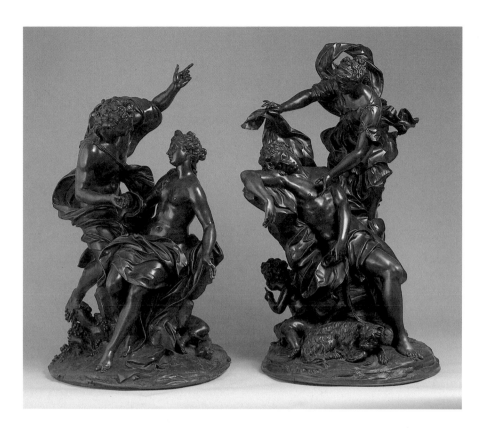

CORNEILLE VAN CLEVE
French, Paris, 1646–1732
*Bacchus and Ariadne*, ca. 1704
Bronze, 27½ in. (69.9 cm)
*Diana and Endymion*, ca. 1704
Bronze, H. 29 in. (73.7 cm)
Gift of Archer M. Huntington
1931.153–154

Both bronzes were certainly conceived as pendants, as casts of these sub-
jects by van Cleve were exhibited together in the Salon of 1704; *Diana and
Endymion* is listed in the 1715 inventory of the collection of Augustus the
Strong in Dresden. The *Bacchus and Ariadne* may reflect the composition
of a marble group of the same subject, planned by van Cleve in 1702 for
the Grande Pièce d'Eau at Louis XIV's Château de Marly.

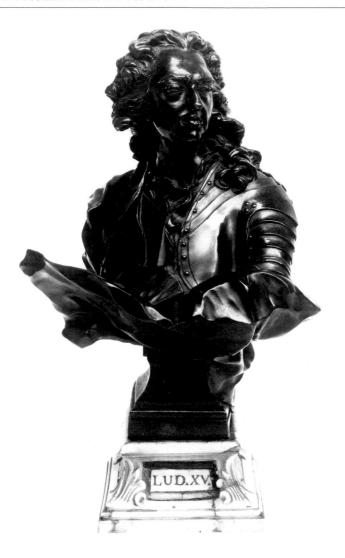

JEAN-BAPTISTE II LEMOYNE
French, 1704–1778
*Portrait Bust of Louis XV*, 1742
Bronze, H. 16⅛ in. (41 cm)
Gift of Archer M. Huntington
1927.210

Jean-Baptiste II Lemoyne was the official portraitist of Louis XV. This is
one of several bronze busts made by him between 1737 and 1751, probably
modeled after engraved portraits, and for court use. Dressed in armor and
wearing the order of the Saint-Esprit, the king is shown as a vigorous,
youthful hero.

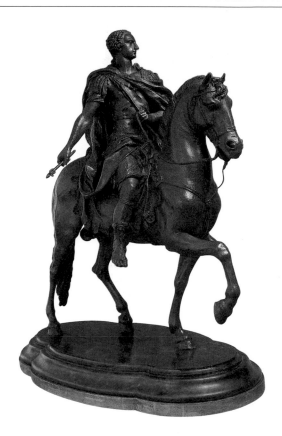

ATTRIBUTED TO TOMMASO SOLARI
Italian, Genoa, d. 1779
*Equestrian Statue of Charles III*, ca. 1762
(King of Naples and Sicily, 1734–1759;
and King of Spain, 1759–1788)
Wax, H. 30 in. (76.2 cm)
Mildred Anna Williams Collection
1978.8

Probably by Tommaso Solari, this wax
sketch for an equestrian statue of Charles
III reflects Luigi Vanvitelli's design of
1757 for a bronze monument intended
for the Largo dello Spirito Santo (now
Piazza Dante) in Naples. The first de-
sign was made for the proposed statue
by the little-known sculptor Giuseppe
Canart, who planned a monument sim-
ilar to the famous *Marcus Aurelius* in
Rome. His design included an elaborate

tomb-like base decorated with reclining
figures. Canart made a wax model, but
work on this statue had not begun when
Charles III left for Madrid to become
king of Spain. In 1762 Solari was com-
missioned to complete the project. The
Museums' wax, attributed to Solari on
the basis of style, could have been a pre-
sentation model. It follows the prancing
type of equestrian statue of Louis XIV
and Louis XV, with arm extended, rather
than the animated, rearing type preferred
by the Spanish monarchs of the seven-
teenth century. The change in pose may
reflect the monarch's desire to identify
with the classical image of authority
favored by the French. Solari's full-scale
stucco model was exhibited in 1764, but
by 1767 the city's funds were depleted
and the project was abandoned.

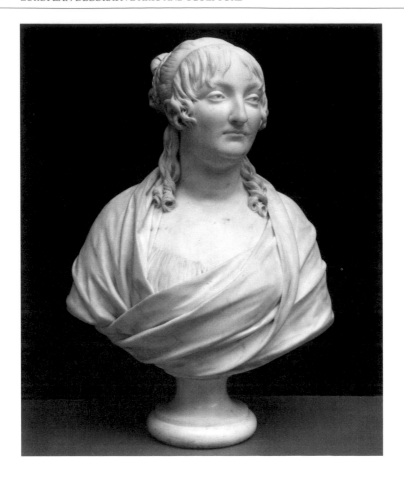

JEAN ANTOINE HOUDON
French, 1741–1828
*Portrait Bust of Madame Adrien-Cyprien Duquesnoy*, ca. 1805
Marble, H. 26¾ in. (68 cm)
Roscoe and Margaret Oakes Collection
54.9

Madame Duquesnoy was the wife of the mayor of Nancy. From 1804 her
husband also served as mayor of the tenth arrondissement of Paris, and in
1805 he presided over the marriage of Houdon's eldest daughter. This bust
has a pendant representing the husband, signed by Houdon (Musée du
Louvre). The portrait of Madame Duquesnoy came to this collection from
her family.

Houdon was probably the greatest sculptor of the eighteenth century.
His virtuoso carving imparts an unparalleled naturalism to his work. While
the restrained details of Madame Duquesnoy's costume suggest a date early
during the Directoire, her melancholic expression is more consistent with
the later date of 1805.

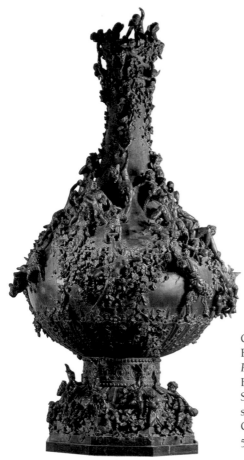

GUSTAVE DORÉ
French, 1832–1883
*Poème de la vigne*, 1877–1878
Bronze, H. 11 ft. (3.35 m)
Signed and dated: *G<sup>ve</sup> Dore;*
stamped: *Thiébaut-Frères-Fondeurs 1877–8*
Gift of M. H. de Young
53696

Gustave Doré, best known as a painter and illustrator, tried his hand at sculpture in 1871, producing a number of highly original works. His *Poème de la vigne* was perhaps inspired by such eighteenth-century romantic fantasies as Clodion's project for the Montgolfier Balloon Monument of 1784–1785. The eleven-foot-tall vase was an ambitious undertaking both artistically and technically. Covered with bacchic figures, it was a sculptural realization of *La dive bouteille*, designed by Doré to illustrate the works of Rabelais, published in 1854 and engraved by Paul Jonnard-Pacel.

The sculpture was received as a bizarre curiosity by Doré's critics. The plaster model, now lost, was exhibited in the Salon of 1878 and the Paris Exposition Universelle of that year. It was not reproduced in bronze until 1882, at a great cost to the artist himself. However, the artist had not paid the foundry at the time of his death, and Thiébaut Frères attempted to sell the piece at the Columbian International Exposition of 1893 in Chicago. The attempt was unsuccessful and the piece was sent to San Francisco at the request of M. H. de Young for the California Midwinter Fair of 1894–1895. It was given to the M. H. de Young Museum in 1931.

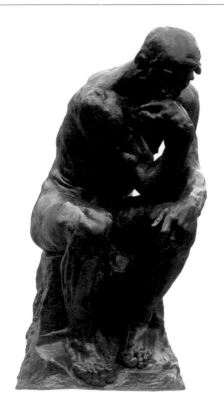

AUGUSTE RODIN
French, 1840–1917
*The Thinker*, ca. 1880, cast ca. 1904
Bronze, H. 6 ft. 6 in. (2 m)
Signed: *A. Rodin*; stamped:
*Alexis Rudier / Fondeur. Paris.*
Gift of Alma de Bretteville Spreckels
1924.18.1

Rodin's *Thinker* is perhaps his best-known monumental work, first conceived ca. 1880–1881 as the poet Dante. The image evolved until it no longer represented Dante, but all poets or creators.

The work was designed to occupy the center of the tympanum of *The Gates of Hell*, which were intended to be a portal of a new Musée des Arts Décoratifs in Paris. *The Thinker* was designed as an independent figure almost from the time the *Gates* were composed, and was exhibited in Paris in 1889 at the Exposition Monet-Rodin at the Galerie Georges Petit. A bronze cast dated 1896 at the Musée d'Art et d'Histoire in Geneva reproduces the original twenty-seven-inch version. The first overlife-size enlargement was exhibited at the Salon of 1904. At this time a subscription was begun for the most famous cast of it,

that for the city of Paris, which was placed in front of the Panthéon.

Bronze casts of the large *Thinker* were not made by Rodin himself, but by a professional *reducteur*, Henri Lebossé, under the artist's supervision. The first large bronze (University of Louisville) was cast by A. A. Hébrard in 1904 for the Louisiana Purchase Exposition in Saint Louis, but was rejected by the artist. Rodin turned principally to the founder Alexis Rudier for subsequent casts, and the Museums' example is one of several commissioned during Rodin's lifetime. Mrs. Spreckels purchased it from Rodin in 1915 through their mutual friend, Loïe Fuller. *The Thinker* is one of the earliest acquisitions of the more than seventy Rodin sculptures that Mrs. Spreckels purchased and later donated to the California Palace of the Legion of Honor.

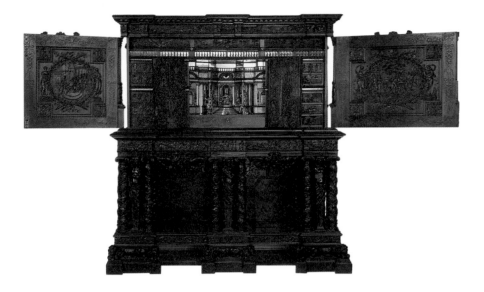

CABINET ON STAND
Attributed to Jean Macé, ca. 1602–1672
French, Paris, after 1641
Ebony, inlay of various woods, tinted
ivory, and colored hardstones; gilt-
bronze figures; 90½ × 87½ × 30 in.
(229.9 × 222.3 × 76.2 cm)
Gift of William Randolph Hearst
47.20.2

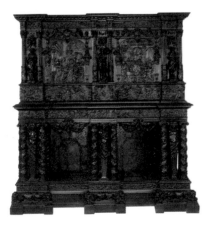

This cabinet follows a type produced for
the French court during the reigns of
Maria de' Medici and Louis XIII. It is
attributed to Jean Macé, who became
*ébéniste du roi* in 1641, working for both
Louis XIII and Louis XIV. Jean Macé was
one of the most important furniture
makers in the royal court before the
famous André-Charles Boulle.

Macé used a number of scenes from
the Old Testament as models for the
reliefs on the interior and exterior of
the cabinet. The reliefs on the exterior
doors seem to derive from Simon Vouet
and the others from woodcuts by Jean
Cousin that appeared in the 1612 edition

of Jean Le Clerc's *Figures historiques du
Vieux Testament.*

The doors of this cabinet open to
reveal a baroque *theatrum mundi* (theater
of the world). On an ornate stage with
receding perspective, gilt-bronze figures
reenact the crucial moment of the Judg-
ment of Solomon. One figure is missing.
This scene is modeled after an engraving
by Mattheas Merian the elder (1593–
1650), which was in Macé's library.

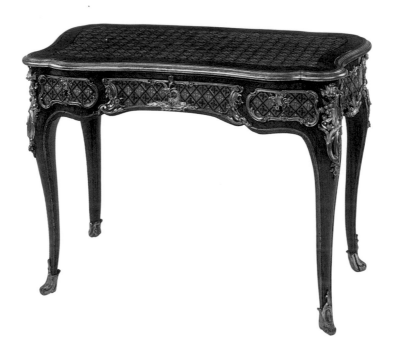

WRITING TABLE (*TABLE À ÉCRIRE*)
Attributed to Bernard II van Risen Burgh,
*maître* before 1730–1766/67
French, 1745–1749
Mahogany, with marquetry of mother-of-
pearl and horn, stained red and green;
gilt-bronze mounts; 27 × 34 × 20½ in.
(68.6 × 86.4 × 52.1 cm)
Stamped: Crowned *C* (mounts)
Gift of Archer M. Huntington
1926.115

This small desk, which came from the
Lelong Collection, Paris (1903), is a feat
of design ingenuity, subtly combining a
variety of materials into intricate geo-
metric and floral patterns carefully inte-
grated with finely tooled gilt-bronze
mounts. This style is typical of the mas-
ter who signed similar examples of his
work *B.V.R.B.* The mount in the form of
a dolphin (the emblem of the dauphin of
France) over the keyhole in the center
suggests a royal provenance.

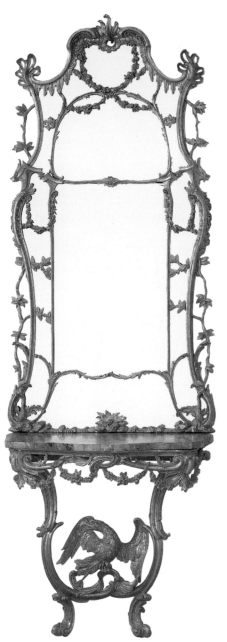

ONE OF A PAIR OF CONSOLE
TABLES AND MIRRORS
After a design by John Linnell,
1729–1776
English, London, ca. 1755–1760
Gilt wood, 119⅝ × 40 × 21 in.
(304 × 101.5 × 53.5 cm)
Gift of The Charles E. Merrill
Trust Fund through Mr. and Mrs.
Robert A. Magowan
76.10 a – b

John Linnell was one of the preeminent
cabinetmakers who worked in the rococo
style in England in the last quarter of
the eighteenth century. The consoles
and mirrors closely follow drawings by
John Linnell in the Victoria and Albert
Museum; the quality of their carving
suggests they were made in his work-
shop. While it is not known for whom
they were made, they came to the
Museums from Boreham House, Essex.

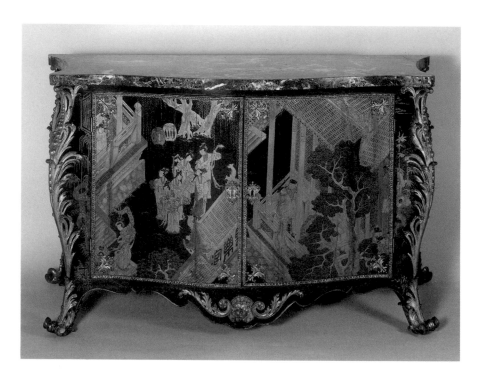

COMMODE
Attributed to Pierre Langlois, 1738–1781
English, 1763
Japanese lacquer, English japanned oak, gilt-bronze mounts, *verde antico*
marble veneer top; 34⅞ × 58¼ × 23⅜ in. (88.5 × 148 × 59.5 cm)
Gift of Mrs. William P. Roth
1985.58

This is one of a pair of black- and gold-lacquer commodes (the mate is now
in the Museo de Arte Decorative, Buenos Aires) *en suite* with four corner
cabinets made by Pierre Langlois in 1763. Langlois was a French cabinet-
maker whose work in the Louis XVI style appealed to English taste in the
mid-eighteenth century. The commodes and the cabinets were made for Sir
Horace Walpole's Gallery at Strawberry Hill, and are listed in his accounts.

*CANAPÉ À LA TURQUE*
Made by François II Foliot, b. 1748, *maître* 1763
After a design by Jacques Gondoin, 1737–1818
Beech, painted gray and white, partially gilded;
39½ × 91½ × 32 in. (100.3 × 232.4 × 81.3 cm)
Stamped: *G. Jacob* (under front seat rail), *maître 1765*
Roscoe and Margaret Oakes Collection
57.23.5

This is undoubtedly the *canapé à la turque* that was part of a large suite commissioned by Marie Antoinette in 1779 for her *grand cabinet-interieur* at Versailles. Other pieces from the suite are now in private collections, Versailles, The Metropolitan Museum of Art, and The New-York Historical Society. Only the latter bears some of the original fabric, otherwise known from a fragment in the Gulbenkian Museum, Lisbon, and from archival description.

The Museums' canapé is apparently the only piece in the suite originally to have been painted as well as gilt. Although several carvers worked on the set, the frames were assembled by Foliot. However, this and the pair of canapés at Versailles bear the stamp of Georges Jacob. Seams on the crest rail and apron indicate the canapé was cut down at a later time. Marie Antoinette's apartments were remodeled in 1783, and the color scheme changed to white and gold. Jacob supplied the furniture for the new apartments. It is possible that this piece, from Foliot's original set, was altered by Jacob for the remodeling, which may explain the presence of his stamp. However, why Jacob stamped the piece that is documented as the work of someone else is not really known.

CABINET
Made by Martin Carlin, 1730–1735, *maître* 1766
French, ca. 1770–1780
Ebony, Japanese-lacquer veneer, gilt-bronze mounts;
33 × 45½ × 19½ in. (83.8 × 115.6 × 49.5 cm)
Stamped: *M. Carlin JME* (twice)
Gift of Archer M. Huntington
1931.145

Carlin was one of a number of cabinetmakers who came to Paris from
Germany in the last half of the eighteenth century. He trained under Jean-
François Oeben. Working to a large extent with lacquer panels, often set with
hardstone or porcelain plaques, Carlin epitomized the Louis XVI taste for
chinoiserie. The lacquer panels of this cabinet, which do not appear to have
been glued, are in an extraordinary state of preservation. The chasing of the
mounts and the tooling of the gilding are also of the highest quality. The clear
geometric lines of this piece illustrate the classicistic taste of this period.

SECRETARY SAFE (*SECRÉTAIRE À ABBATANT*)
Made by Paolo Moschini, b. 1789
Italian, Cremona, 1882
Elm veneer, gilt-bronze mounts;
66½ × 48¾ × 26 in. (168.9 × 123.8 × 66 cm)
Signed and dated: *Pavolo Moschini/di Sancino/Inventò disegnò e fece/1822*
Museum purchase, William H. Noble Bequest Fund
78.61

Hidden safes, opened by a series of intricate mechanical devices, are contained in the upper and lower parts of this drop-front secretary. It was made by Moschini as part of the bedroom suite of Maria Luisa of Austria, second wife of Napoleon, and grand duchess of Parma, Piacenza, and Guastalla from 1814, for her Villa Croara at Piacenza.

PORRINGER AND STAND
Made by R. F.
English, London, 1662
Silver, porringer H. 8 in. (20.3 cm),
stand diam. 16½ in. (41.9 cm)
Roscoe and Margaret Oakes Collection
76.4 a–c

These masterpieces of Restoration silver
illustrate the sculptural talents of English
silversmiths during the seventeenth cen-
tury. Silver made in the late Stuart period
was commonly hammered from thin
plate and embossed with bold floral and
animal motifs borrowed from Holland.
The serpent-form handles and cover
knob are cast.

HOT-WATER URN
Made by Martin-Guillaume Biennais,
1764–1843, active 1789–1819
French, Paris, 1809–1819
Silver gilt, carnelian; H. 19¼ in. (48.9 cm)
Inscribed: *Biennais, Orfévre* [sic] *de S. Mté.*
*l'Empereur et Roi à Paris*
Gift of Alma de Bretteville Spreckels
1944.11

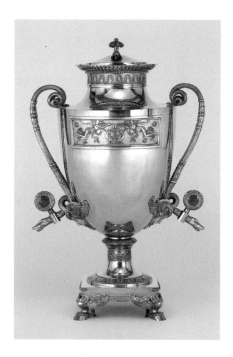

The Museums are fortunate to own a
sizable collection of eighteenth-century
French silver, 220 pieces from the
Catherine D. Wentworth Collection, and
a number of impressive neoclassical
pieces such as this, purchased by Alma
de Bretteville Spreckels. This hot-water
urn must have been part of one of the
vast services made by Biennais as offi-
cial goldsmith to Napoleon. During the
Empire, Biennais operated an extensive
workshop of highly skilled goldsmiths
who mass-produced jewelry and large
quantities of sumptuous silver for both
Napoleon's entourage and the courts of
Europe. This piece was modeled by
Biennais after a tea urn (*fontaine à thé*)
made by Henri Auguste in 1803 for

Queen Hortense, daughter of Josephine
and wife of Louis Bonaparte. Biennais
may have purchased the drawing of it
at Auguste's bankruptcy sale in 1810.

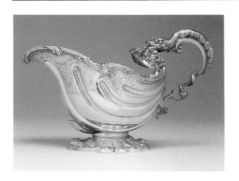

ONE OF A PAIR OF SAUCEBOATS
Made by Paul Storr, 1771–1844
English, London, 1819
Silver, 6⅛ × 9⅞ × 4½ in.
(15.5 × 25 × 11.5 cm)
Roscoe and Margaret Oakes Collection
70.22.2

From ca. 1811 Storr received numerous
royal commissions and became the most
important London silversmith of the
Regency. The sauceboats show Storr's
debt to the rococo in the fluid integra-
tion of a shell-like shape with a handle
molded in the form of a coiled serpent.
Varied textural surfaces, achieved by
degrees of polish and use of the punch,
show Storr's technical mastery at its best.

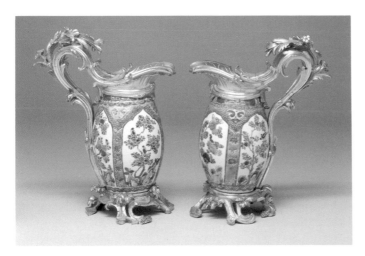

PAIR OF VASES MOUNTED AS EWERS
Porcelain: Chinese, Kangxi period,
1662–1722; mounts: French,
gilt bronze, 1745–1749;
H. 10¼ in. (26 cm)
Stamped: Crowned C
Gift of Archer M. Huntington
1927.170–171

From medieval times Oriental porcelains
were mounted in silver or gilt silver as an
indication of their value. Beginning in
1684–1686, mounted porcelain became

especially popular at the French court,
which set the fashion for all of Europe.
From about 1741, when the Crown
purchased its first piece of Oriental por-
celain mounted in gilt bronze, it became
the preferred material, rather than pre-
cious metals. The mounts were typically
modeled with an elaboration of crisply
chiseled flowers, leaves, reeds, and shells
in the rococo style. The crowned C was
a tax mark used exclusively between
1745 and 1749.

SALTCELLAR
French, Saint Porchaire factory,
ca. 1530–1560
Lead-glazed earthenware (faïence fine),
8⅝ × 5¾ in. (21.9 × 14.6 cm)
Inscribed: on volutes, monogram DH;
on bowl interior, monogram of the
crescent moons of Diana, goddess
of the hunt
Museum purchase, the Ruth L. and
Alfred B. Koch, Sr., Memorial Fund;
Roscoe and Margaret Oakes Income
Fund; the Mrs. Mildred Browning Green,
Mrs. Elizabeth Hay Bechtel, and Bing
Crosby Art Trust Funds; and funds
from various donors
1986.6

The pottery of the Saint Porchaire
factory is among the rarest and most
highly prized today. Possibly founded
under the patronage of the Montmorency
family, who occupied a prestigious place

in the French court, the factory developed
very fine, fragile earthenware. This piece
was probably conceived as an elaborate
table decoration for aristocratic amuse-
ment, rather than for use.

The style of this tall saltcellar prob-
ably owes to Italian goldsmith-work,
popular in the Fontainebleau court dur-
ing the mid-sixteenth century. Its form
is inspired by French architecture of this
period, as seen in engravings by Jacques
Androuet Ducerceau or Sebastiano Serlio
in the 1540s. The three nude figures of
the Virtues and the bound male nude
in the interior probably derive from
drawings by Michelangelo, which were
current in the French court by 1532. The
shields held by the Virtues bear the royal
crown and fleur-de-lys. The inscribed
monogram DH represents Henri II, king
of France, and Diane de Poitiers, his mis-
tress. The interlaced crescent moons are
her monogram.

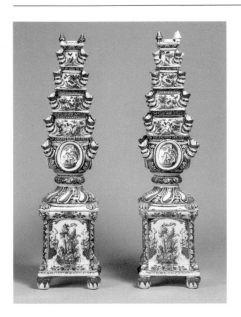

PAIR OF TULIP VASES
Made by Adriaenus Koeks, 1687–1701
Dutch, Delft, Greek A factory, ca. 1690
Tin-glazed earthenware, H. 39⅜ in.
(100 cm)
Mark: O
          AK
Bequest of Frances Adler Elkins
55.9.1 a–f and 55.9.21 a–f

Flower pyramids made of blue- and
white-painted earthenware were pop-
ular during the last quarter of the
seventeenth century. They appear in
prints by Daniel Marot, who is also
known to have created designs for
them.

SAINT WENCESLAUS,
PATRON SAINT OF BOHEMIA
After a model by Johann
Gottlieb Kirchner, b. 1706
German, Meissen factory, ca. 1732
Hard-paste porcelain, H. 18 in. (45.7 cm)
Mark: Crossed swords in underglaze blue
Museum purchase, Roscoe and Margaret
Oakes Income Fund
1985.33

The factory of Augustus the Strong, king
of Saxony and Poland, was the first Euro-
pean porcelain factory to successfully
produce true hard-paste porcelain.
Johann Gottlieb Kirchner was the first
master modeler employed at Meissen by
the king in 1731 to carry out the vast
monumental porcelain decorations of his
Japanese palace. Kirchner's stay at Meis-
sen, however, was short-lived, and works
from his hand are rare.

   Documents indicate Kirchner made
two figures of this model in 1732; one
failed in the kiln, and the other was
destroyed in Dresden during World
War II. The style of the modeling, the
color, texture, and the facture of the paste

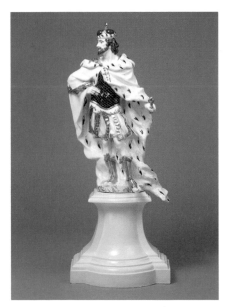

as well as the appearance of the mark on
the existing figure indicate that it is
contemporary with the figure that was
destroyed. It is the only known poly-
chromed version, and may have sur-
mounted an elaborate porcelain base
decorated with military trophies and genii.

COVERED TUREEN
French, Chantilly factory, ca. 1745
Soft-paste porcelain, 6 × 8½ × 7½ in.
(15.2 × 21.6 × 19.1 cm)
Gift of Mrs. Constance Bowles Hart
1986.34 a–b

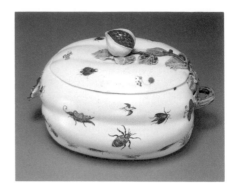

The Chantilly factory was one of the
most distinguished that flourished in
France in the mid-eighteenth century.
Founded in 1725 under the patronage
of Louis Henri de Bourbon, prince de
Condé, it became known before 1751
for the whiteness of its products, fired
with a tin glaze that enhanced their
vividly colored decoration. The asym-
metrical, lobed shape of this tureen
probably derived from a piece of Arita

porcelain in the prince's collection. The
precisely painted flowers and insects,
outlined in black, are influenced by
those painted at Meissen about ten years
earlier.

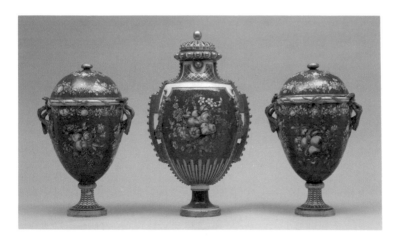

SET OF THREE COVERED VASES
French, Sèvres factory, 1768
Soft-paste porcelain,
H. center vase 19 in. (48.3 cm),
smaller vases 15½ in. (39.4 cm)
Gift of Archer M. Huntington
1927.184, 185, 186

The dark blue ground color of these
vases is probably *bleu du roi*, overpainted
with an *oeil de perdrix* pattern. The cen-
tral vase is decorated front and back with
painted bunches of fruit and flowers. The
two flanking vases, *vases à oeuf*, have
similar decoration. One is marked with
the date letter for 1768 and is incised *a.p.*,
the mark of the former of the vase. The
three vases may have been part of a larger
*garniture*.

PERFUME BURNER
IN THE SHAPE OF A DOVECOT
English, Chelsea, ca. 1754
Soft-paste porcelain, 16¾ × 8½ in.
(42.5 × 21.6 cm)
Mark: red anchor
Gift of Mrs. Constance Bowles Hart
in memory of Henry Bowles
1986.45

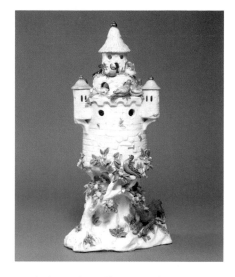

The Bow and Chelsea factories were the
first to produce porcelain in England,
ca. 1745. Naturalistic forms, either
painted or modeled in porcelain, became
a trademark of the Chelsea factory. This
work is listed in its 1755 catalogue:
"A most beautiful perfume pot, in the
form of a pigeon house, with pigeons, a
fox, etc." Although this subject may not
be directly derived, animal subjects from
Aesop's fables were particularly favored
at Chelsea. This tall vase, with its com-
plexly applied flowers, leaves, birds,
and animals, is a masterwork of firing.

SALVER
French, Limoges, 1575–1585
Enameled by Jean de Court,
active 1550–1585
Enamel in *grisaille* on copper,
21¼ × 16 in. (54 × 40.6 cm)
Signed: *I. C.* (reverse)
Gift of Mr. and Mrs. George Wagner
48.2

The great period of enamel production at
Limoges was 1530–1585. Like ceramics,
enamels were popular forms of luxury
decoration for the *cabinet* and for other
interior architecture as well, even in-
tended for the Galerie of François I at
Fontainebleau.
 The scene on this salver represents
Moses parting the waves and probably
derives from a contemporary engraving
of biblical scenes. The artist, Jean de
Court, was best known as a painter and
succeeded Francois Clouet in 1572 as
painter to Charles IX (reigned 1556–
1574). The ornamental designs after
the antique that border this salver, both
front and back, are based on engravings
by Jacques Androuet Ducerceau and by
Etienne Delaune from the 1570s.

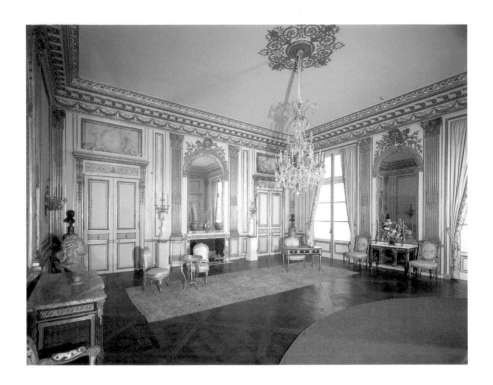

SALON
From the Hôtel d'Humières, 16 rue de Bourbon
(now 88–90 rue de Lille), Paris
French, ca. 1770–1773
Painted and gilt wood
Gift of Mr. and Mrs. Richard S. Rheem
1959.123

This room installed at the Legion of Honor follows the classical style of
the Louis XVI period, with gilt ornament and walls painted a light color.
It comes from a house in the faubourg St. Germain, built in 1716–1717 by
the architect Armand-Claude Mollet (active 1692–1742) for the marquis
d'Humières, grand master of artillery for Louis XIV. In 1728 the house
passed to the duc de Gramont, then to the duc de Fleury, who lived there
from 1750–1779 and must have been responsible for the decorative style
of this room.

# EUROPEAN
# PAINTINGS

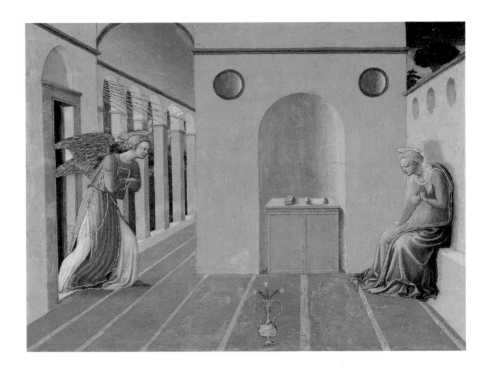

MASTER OF THE LANCKORONSKI ANNUNCIATION
Italian, Florentine, active ca. 1445–1450
*The Annunciation*
Tempera on panel, 10 × 13 in. (25.5 × 33 cm)
Gift of The de Young Museum Society
54.3

The diminutive size of this work was surely dictated by its original use as
a *predella* panel for an unidentified altarpiece. Unfortunately, although
the names of Domenico Veneziano, Filippo Lippi, Fra Angelico, and, most
recently, Giuliano Pesello have been linked with this panel, the identity of
its author remains elusive. Nonetheless, the painting demonstrates the
interests and contradictions characteristic of Florentine painting in the
mid-fifteenth century. Clinging to decorative gothicizing details, the artist
attempted to create a convincing and measurable space for his figures.
The calm balance and harmony established by the architectural setting
is reinforced in the delicate color scheme.

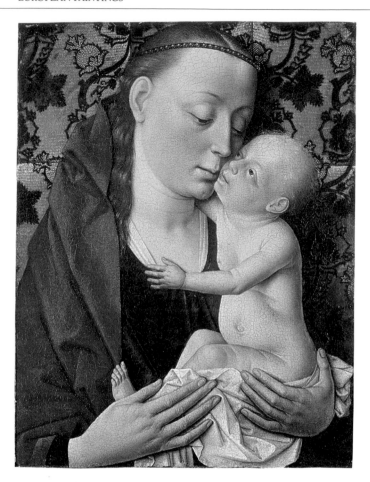

DIERIC BOUTS
Flemish, ca. 1415–1475
*Madonna and Child*, ca. 1460
Oil on panel, 10¼ × 7¾ in. (26 × 19.5 cm)
Roscoe and Margaret Oakes Collection
75.2.14

This tender portrayal of mother and child reflects the Renaissance desire
to characterize the most holy Christian personages in terms of ordinary
human experience. Represented before a courtly cloth of honor, the Virgin
and Infant Christ interact as any earthly mother and child. The novel emo-
tional realism is coupled with a northern richness of color and attention to
detail. The artist delighted in differentiating the textures of hair, skin, jewels,
and brocaded cloth. The best of three versions of the composition by Bouts,
this panel is in superb condition.

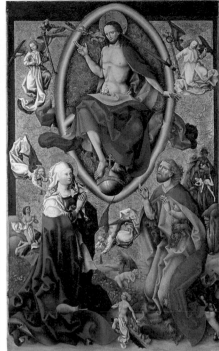

UNKNOWN TYROLEAN MASTER
Active in Ottobeuren in the Allgau, ca. 1500
*Last Judgment Triptych*
Oil on panel

| Central panel: | Side panels: |
|---|---|
| 57⅝ × 34⅜ in. | Each 27¼ × 15¾ in. |
| (146.5 × 87.5 cm) | (69 × 40 cm) |
| Gift of the Samuel H. Kress | Museum purchase, |
| Foundation | Art Trust Fund |
| 61.44.32 | 1981.18 a–d |

Conservative German artists continued to feel the influence of late medieval
art forms and religious symbolism well into the sixteenth century. The flat
abstract gold background and the hieratic figural scale of the recently re-
united panels of this altarpiece illustrate this conservatism. Yet the vibrant
color scheme and the intricacy of the drapery patterns are evidence of this
unknown artist's great skill. The symbolism of the Last Judgment is manifest
in the hosts of angels and the Christ in glory. Armed with the lily (iris) of
mercy and the double-edged sword of justice, he sits in judgment of human
souls. Mary his Mother and Saint John the Baptist kneel at Christ's feet,
interceding on behalf of the Christian faithful.

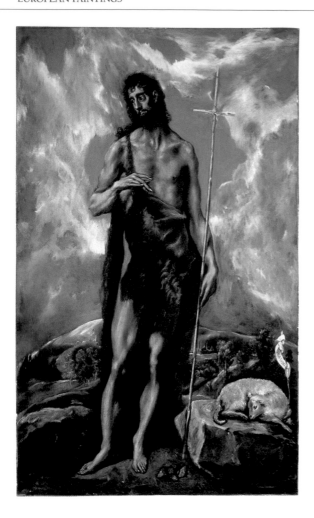

DOMENIKOS THEOTOKOPOULOS,
called EL GRECO
Spanish, born in Crete, 1541–1614
*Saint John the Baptist*, ca. 1600
Oil on canvas, 43¾ × 26⅛ in.
(111 × 66.5 cm)
Signed in Greek minuscule on rock lower
right: *domenikos theotokopolis* [sic] *e' poiei*
Museum purchase, gift of various donors
46.7

El Greco used a mannerist elongation
of the body to emphasize the ascetic
nature of Saint John the Baptist, the
last of the Old Testament prophets who
preached the coming of the Messiah. To
suggest the saint's spiritual energy, the
painter activated the entire composition.
Broken brushstrokes delineate the undu-
lating forms of man, landscape, and
clouds, creating a flickering pattern of
light. This work was painted for the con-
vent of the Descalced (barefoot) Carmel-
ites in Malagón, where it remained
until 1929. It is El Greco's most brilliant
representation of Saint John the Baptist.

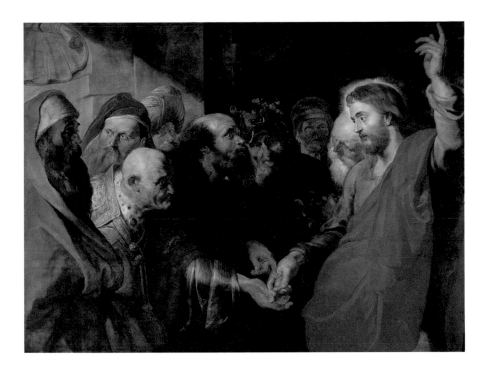

PETER PAUL RUBENS
Flemish, 1577–1640
*The Tribute Money*, ca. 1612
Oil on panel, 56¾ × 74¾ in. (144 × 190 cm)
Purchased with funds from various donors
44.11

This work illustrates the crucial passage in the episode described in Matthew 22: 15–22. In reply to the Pharisees' question about whether it is lawful to pay taxes, Christ calls attention to Caesar's image and inscription on a coin and states, "Render therefore to Caesar the things that are Caesar's, and to God the things that are God's."

This work dates from the period of Rubens's early maturity, when he painted *The Raising of the Cross* of 1610–1611 and *The Descent from the Cross* of 1611–1614 (both Antwerp Cathedral). This extraordinary northern baroque painting reflects many of the influences that the artist absorbed while in Italy between 1600 and 1608. For example, the composition organized around a group of half-length figures seems to depend on a Venetian prototype, and the emphasis on chiaroscuro and penumbra indicates a strong interest in the work of Caravaggio. Not surprisingly, *The Tribute Money* seems to have been very popular from the moment it was painted; Jordaens and van Dyck were influenced by it, Vorstermann engraved it in 1621, and numerous copies exist.

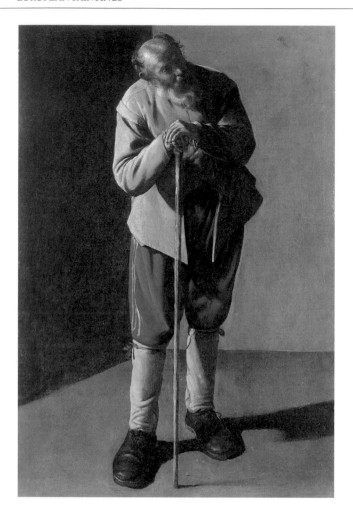

GEORGES DE LA TOUR
French, 1593–1652
*Old Man*, ca. 1618–1619
Oil on canvas, 35⅞ × 23¾ in.
(91 × 60.5 cm)
Roscoe and Margaret Oakes
Collection
75.2.9

Georges de La Tour of Lorraine, one
of the most original and certainly
today one of the most popular French
seventeenth-century artists, was redis-
covered in 1932. His oeuvre was pains-
takingly assembled and now numbers
about forty compositions, although
problems of attribution and chronology
remain controversial among art histor-
ians. La Tour stressed the value of
human life, no matter how humble or
fragile. He often depicted workers, beg-
gars, or blind men with their physical
defects or signs of old age clearly de-
scribed. *Old Man* and *Old Woman* are

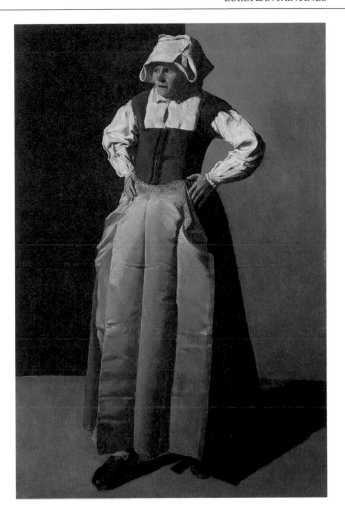

among La Tour's earliest works. However, their costumes, particularly the woman's embroidered silk apron, suggest that these are not simple peasants, but rather stock figures from popular theater, the domineering wife and the hen-pecked husband. The harsh lighting emphasizing the shadows may come from footlights, but this technique shows the influence of the Italian artist Caravaggio or the Utrecht masters who imitated him. La Tour's skillful execution and highly refined use of color combine here to create figures of classical monumentality.

*Old Woman*, ca. 1618–1619
Oil on canvas, 36 × 23⅝ in.
(91.5 × 60.5 cm)
Roscoe and Margaret Oakes
Collection
75.2.10

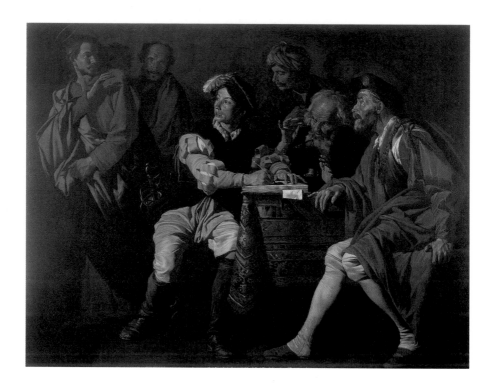

MATTHIAS STOMER, or STOM
Dutch, ca. 1600–ca. 1650
*The Calling of Saint Matthew*, ca. 1629
Oil on canvas, 68⅞ × 88³⁄₁₆ in. (175 × 224 cm)
Roscoe and Margaret Oakes Income Fund
1986.27

This painting illustrates the moment when Christ enters a tax office and
with the words "Follow me" exhorts Matthew to leave his work as a tax
collector and become one of his disciples (Matthew 9:9–13). The size,
subject, and style of this work suggest that it was probably painted for a
church during Stomer's Roman period, ca. 1628–1633. While *The Calling
of Saint Matthew* reflects the influence of Stomer's Utrecht contemporaries,
especially Terbrugghen and Baburen, the palette and the bold use of light
and shadow indicate that the artist has looked carefully at works by
Caravaggio such as the *Christ at Emmaus* (private collection, Bellagio),
which he could not have known until his arrival in Rome. Indeed, the
relatively untempered influence of Caravaggio suggests that this work
must have been executed within about a year of Stomer's arrival in Rome.

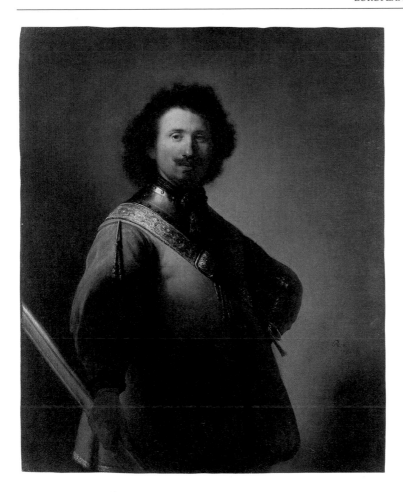

REMBRANDT HARMENSZ. VAN RIJN
Dutch, 1606–1669
*Portrait of Joris de Caullery*, 1632
Oil on canvas affixed to panel,
40⅜ × 33 in. (102.5 × 84 cm)
Signed and dated lower right:
*RHL van Rijn / 1632*
Roscoe and Margaret Oakes Collection
66.31

A document of 1654 identifies the sitter as "the Noble and Valiant Joris de Caullery, Captain at sea in the service of [the Netherlands]." In this portrait of 1632, de Caullery is portrayed as a member of a citizens' militia. He carries a firearm known as a caliver in his right hand; the bandolier and cross-hilted cavalry sword indicate that he is an officer. By 1635 he was a lieutenant in one of the six companies of militia in The Hague.

Painted in the same year as the famous *Doctor Tulp Demonstrating the Anatomy of the Arm* (Mauritshuis, The Hague), this work demonstrates the astonishing power of Rembrandt at the age of twenty-six. The exacting treatment of detail and surface characteristics, the psychological realism, and the richly orchestrated lights, darks, shadows, and halftones combine to create one of his most outstanding early portraits.

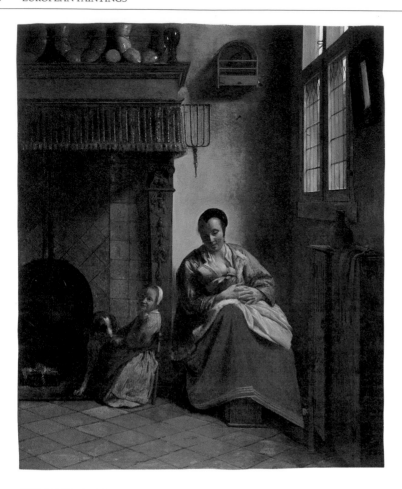

PIETER DE HOOCH
Dutch, 1629–1684
*Interior with Mother and Children*, ca. 1658–1660
Oil on canvas, 26⅝ × 21⅞ in. (67.5 × 55.5 cm)
Signed indistinctly on footwarmer: *P. d Hooch*
Gift of the Samuel H. Kress Foundation
61.44.37

Among the most popular and beautiful seventeenth-century Dutch paintings
are domestic interiors by Vermeer and de Hooch. In this relatively early but
outstanding example de Hooch celebrates the virtues of family life, focusing
on the nurturing role of a mother who is imitated by her young daughter.
The central theme is supported by several symbolic references. The caged
bird refers to the the bonds of marriage, the cupid decorating the framing
element of the right side of the hearth is a symbol of love, and the dog is
associated with fidelity and vigilance. There is a slightly later variant of this
composition in the Wallace Collection, London.

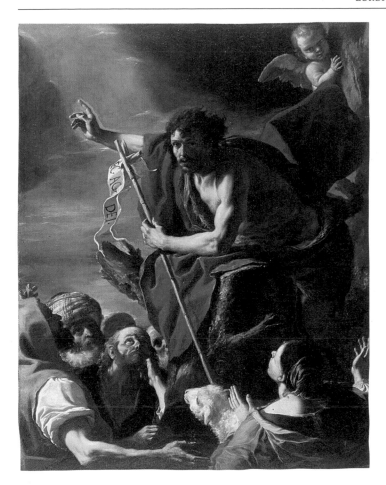

MATTIA PRETI
Italian, 1613–1699
*Saint John the Baptist Preaching*, ca. 1660
Oil on canvas, 85½ × 67 in. (217 × 170 cm)
Museum purchase, Roscoe and Margaret Oakes
Income Fund and Kathryn Bache Miller Fund
1981.32

This painting, from Preti's most creative phase, demonstrates his response
to the combined artistic stimuli of seventeenth-century Rome, Venice,
Emilia, and Naples. Characteristic of Italian baroque art, the artist attempts
to draw the spectator into the painted world. Here the viewer is confronted
directly by the gaze of a heroic, virile Saint John the Baptist. His pose creates
a dynamic diagonal both across and into the pictorial space. The baroque
power of the work is the result of monumental scale and theatrical compo-
sition joined by dramatic lighting effects.

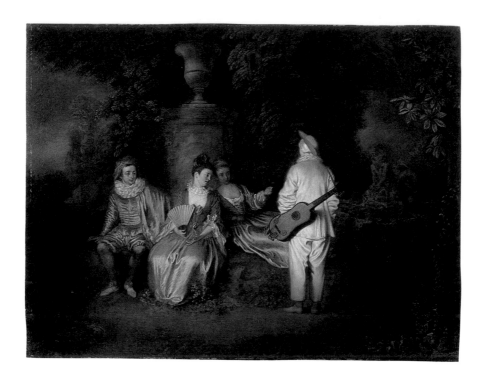

JEAN-ANTOINE WATTEAU
French, 1684–1721
*The Foursome (La partie quarrée)*, ca. 1713
Oil on canvas, 19½ × 24¾ in. (49.5 × 63 cm)
Mildred Anna Williams Collection
1977.8

One of the greatest French painters, Watteau remains an enigma. He came to
Paris from his native Valenciennes, then part of Flanders. Through exposure
to the theater, important collections of various Parisian *amateurs*, and, in
particular, through his study of Rubens and the Venetian painters, Watteau
evolved a highly personal style, characterized by the delicate palette and
luminous effects of the rococo as well as a sensitivity to atmosphere. His
*fêtes galantes* depict fashionable ladies and gentlemen in an Arcadian dream-
land of music, conversation, and amorous dalliance. Although the term can
be defined simply as a party with two couples, the licentious implication of
*La partie quarrée* has changed little since the eighteenth century. As the last
rays of the sun give their costumes a brilliant sheen, four characters from
the *Commedia dell'Arte* (Pierrot, Mezzetin, and their ladies) converse in a
park, but the meaning of the scene is unknown.

ANNE VALLAYER-COSTER
French, 1744–1818
*Still Life with Plums and a Lemon*
Signed and dated lower right: *Mlle Vallayer / 1778*
Oil on canvas, 16⅜ × 18⅝ in. (41.5 × 47.5 cm)
Gift of Mr. and Mrs. Louis Benoist
1960.30

Vallayer-Coster was one of the most famous artists of the second half of
the eighteenth century, although she is not well known today. She was
elected to the Academy in 1770, exhibited often at the Salon, married a
member of Parliament, and her work was admired by Diderot; but it is not
known with whom she studied. However, the strong resemblance of many
of her still lifes to works by Jean-Baptiste-Siméon Chardin (1699–1779)
indicates a strong affinity if not a direct connection with the slightly older
painter. The subjects and style of her work, in addition to that of Chardin,
seem to have influenced such later artists as François Bonvin (1817–1887)
and Henri Fantin-Latour (1836–1904).

BARON FRANÇOIS-PASCAL-SIMON GÉRARD
French, 1770–1837
*Comtesse de Morel-Vindé and Her Daughter (The Music Lesson)*, 1799
Oil on canvas, 79 × 56¼ in. (200 × 143 cm)
Museum purchase, Mildred Anna Williams Fund
and William H. Noble Bequest Fund
1979.8

Baron Gérard, one of Jacques-Louis David's (1748–1825) most gifted pupils,
stands out among the generation of neoclassical painters who matured in
the 1790s and continued to work well into the nineteenth century. Although
he also produced history and mythological paintings, Gérard excelled as
a portraitist and established his reputation with *Jean-Baptiste Isabey and
His Daughter* (Musée du Louvre), which he exhibited at the Salon of 1896.

   This superb Empire portrait was probably commissioned by Vicomte de
Morel-Vindé, an author, bibliophile, and *amateur par excellence*, whose wife
and daughter are depicted. The room in the painting was a salon in the Hôtel
de Vindé on the boulevard de la Madeleine in Paris. The quasi-photographic
realism, the attention to surface, texture, and detail, and the tight rendering
are characteristic of the work of David and his circle at this time. Evidence
of the turmoil of the Revolution is nowhere to be found, family virtues are
extolled, and the aristocracy and the idea of the aristocracy seem to have
emerged unscathed. Only changes in style—clothing, furniture, and that
of the painting itself—tell us that France and the world have changed.

JOSEPH-SIFFRED (or SIFFREIN) DUPLESSIS
French, 1725–1802
*Portrait of a Gentleman*
(Maître Jean-Baptiste-François Dupré[?]), ca. 1779–1782
Oil on canvas, 57¾ × 44¾ in. (147 × 114 cm)
Mildred Anna Williams Collection
1966.46

Official court painter to Louis XVI, Duplessis was recognized as the leading
portraitist of his generation, rivaled only by Alexandre Roslin. Eighteenth-
century portraits are remarkable as speaking likenesses of their sitters. Here
the presumed Maître Jean-Baptiste-Francois Dupré (1747–1837), dressed
with sober elegance befitting a man of law, greets the viewer in his well-
appointed study. The keenness of observation, attention to detail, brilliant
rendering of materials and flesh tones, and use of the mirror to introduce
another dimension within the painting are typical of Duplessis's talent
and skill.

THOMAS GAINSBOROUGH
British, 1727–1788
*Market Carts*, ca. 1784–1785
Oil on canvas, 50⅜ × 40⅜ in. (128 × 102.5 cm)
Roscoe and Margaret Oakes Collection
75.2.8

Based on a painting by Pieter Molijn (1595–1661), this work reveals the
continuing influence of seventeenth-century Dutch landscape painting on
Gainsborough, even very late in his career. Not only the composition, but
also elements of style such as the feathery treatment of the foliage and a
warm brown tonality link *Market Carts* with the work of the great Dutch
landscapists, including Salomon van Ruysdael. However, the delight Gains-
borough took in describing the rustic scene and the irregularity of the
natural forms is in keeping with the picturesque aesthetic of the eighteenth-
century. The provenance of the painting can be traced back to the collection
of Gainsborough's close friend Samuel Kilderbee of Ipswich, who received
the painting as a gift from the artist.

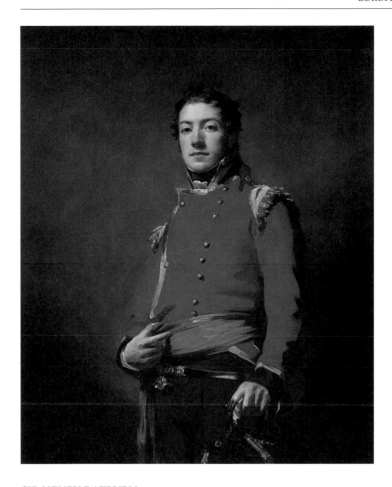

SIR HENRY RAEBURN
Scottish, 1756–1823
*Sir Duncan Campbell, Bart.*, ca. 1815
Oil on canvas, 50⅜ × 40 in. (128 × 101.5 cm)
Roscoe and Margaret Oakes Collection
75.2.12

The uniform of the Third Scots Fusilier Guards worn by the sitter, Sir
Duncan Campbell, the first baronet of Barcaldine, allows Raeburn to
develop a striking color scheme of saturated red and gold against a dark
background. Equally vibrant is the broad, painterly brushwork, which
roughly delineates the forms and spatial relationships. The foremost por-
traitist in Scotland, Raeburn here proves himself a master at capturing the
personality of the sitter. The strident coloration and technique echo the
commanding expression and stance of the aristocratic figure.

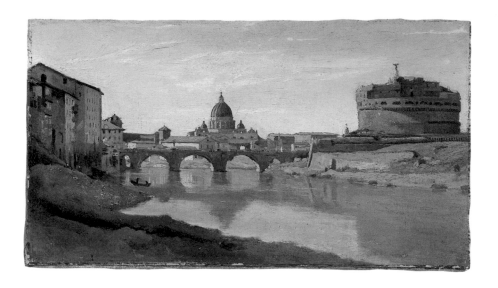

JEAN-BAPTISTE-CAMILLE COROT
French, 1796–1875
*View of Rome: The Bridge and Castel Sant'Angelo
with the Cupola of St. Peter's*, 1826–1827
Oil on canvas, 8⅝ × 15 in. (21.5 × 38 cm)
Stamped (lower left): *Vente Corot*
Museum purchase, Archer M. Huntington Fund
1935.2

This remarkable small painting was executed during Corot's first trip to
Italy (1825–1828). Corot painted several views of the banks of the Tiber near
the Castel Sant'Angelo, all of which seem to have been done in the open air,
but none is more attentive to subtleties of light and color than this example.
Indeed, its extraordinary naturalism has led many authorities to cite *View
of Rome* as the kind of painting that directly influenced the birth of the
impressionist movement. Although works such as *View of Rome* may appear
effortlessly done to the modern viewer, a letter written by Corot from Rome
in spring 1826 suggests that the lessons of plein-air painting were hard won:
"For the whole past month here I have been awakened every single morning
by the brilliance of the sun striking the walls of my room. It is always fine
weather, but on the other hand, this sun radiates the light of my despair.
I become aware of the utter impotence of palette. Honestly, there are days
when I feel like throwing the whole thing to the devil."

EDWARD LEAR
British, 1812–1888
*Masada*, 1858
Inscribed (on stretcher): *Masada (or Sebbeh) on the Dead Sea*
*painted by Edward Lear (from drawings made in April 1858)*
*for Frances Countess Waldegrave. Edward Lear 1858.*
Oil on canvas, 18¾ × 30 in. (47.5 × 76 cm)
Grover A. Magnin Bequest Fund
1986.40

Masada, meaning fortress, is an isolated mountain looming 1400 feet above
the Dead Sea to the east and a desert to the west. Between A.D. 66 and 73 it
was the stronghold of the Jewish Zealots led by Menachem ben-Yehuda in
the revolt against Rome. In A.D. 72–73 the Tenth Roman Legion laid siege
to Masada, and at the end of a two-year struggle the group of 950 Zealots
defending themselves on the mountaintop chose to commit suicide rather
than submit to capture and enslavement.

Influenced by the style and ideas of the Pre-Raphaelite Brotherhood
(Lear considered himself a "Pre-Raphaelite baby"), *Masada* is at once a
topographical record and a symbol. As Lear wrote from Corfu on 27
December 1857 to Chichester Fortescue, for whose wife *Masada* was
painted, "The uppermost subject in my feeble mind just now is my Palestine
visit.... Now my particular idea at the present hour is to paint...*Masada*
whither I intend to go on purpose to make correct drawings.... My reason
for this choice is, that not only [do] I know the fortress of Masada to be a
wonder of picturesqueness, but that I consider it as embodying one of the
extremist developments of the Hebrew character, *i.e.* consistency of purpose,
& immense patriotism."

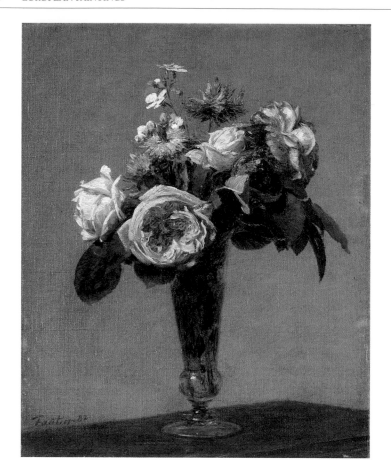

HENRI FANTIN-LATOUR
French, 1836–1904
*Flowers in a Vase*
Signed and dated (lower left): *Fantin. 82*
Oil on canvas, 13⅝ × 10⅞ in. (34.5 × 28 cm)
Given anonymously in memory of Sidney H. Ehrman
1954.58

*Flowers in a Vase* testifies to Fantin-Latour's position as one of the most accomplished still-life painters of the second half of the nineteenth century. Moreover, this work reflects his admiration for such eighteenth-century French still-life painters as Jean-Baptiste-Siméon Chardin and Anne Vallayer-Coster, the influence of the mid-nineteenth-century realist movement, and his exceptional flair for relatively simple but elegant compositions. The lasting appeal of his decorative realism underscores the continuing viability, especially in the marketplace, of an art that includes the best of both academic and avant-garde painting.

GEORGES PIERRE SEURAT
French, 1859–1891
*The Eiffel Tower*, ca. 1889
Oil on panel, 9½ × 6 in. (24 × 15 cm)
Museum purchase, William H. Noble Bequest Fund
1979.48

This view of the Eiffel Tower was a quintessentially modern statement in 1889, but both the subject and Seurat's neo-impressionist style were offensive to most contemporary Parisians. In 1887 a group of conservative but particularly well-known artists and writers attacked the tower as "useless and monstrous." Two years later Pissarro identified it as evidence of social turpitude and bourgeois excess. Nevertheless, Seurat celebrated the tower as a marvel of the modern industrial vernacular, its elegant but bold design a combination of iron, light, and open spaces that dissolves into the surrounding sky. For him the soon-to-be-completed structure was a symbol of progress that was appropriate to his equally modern and controversial technique.

PAUL CÉZANNE
French, 1839–1906
*The Rocks in the Park of the Château Noir,* ca. 1898–1899
Oil on canvas, 24 × 31⅞ in. (61 × 81 cm)
Mildred Anna Williams Collection
1977.4

The thin, watercolor-like application of paint is characteristic of works of
the late nineties, but the parallel and rhythmic brushwork is a direct out-
growth of works of the late eighties and early nineties. Surprisingly, the site
has never been positively identified. Affinities of subject and palette with
a painting of 1892–1894 in the Philadelphia Museum of Art suggest that it
may be a view in the park of the Château Noir near Aix-en-Provence. How-
ever, John Rewald points out that as Cézanne spent much of 1898–1899 in
or near Paris, it is also possible that this work depicts one of the many
boulder-strewn hillsides in the Fontainebleau Forest.

# AMERICAN DECORATIVE ARTS AND SCULPTURE

LOOKING GLASS
Probably retailed by William Wilmerding
American, New York City, ca. 1790
Red spruce, mahogany veneers, and gilt;
H. 64 in. (162.6 cm)
Gift of Davenport Scott, Stuart Scott,
and Mrs. Schuyler M. Meyer in memory
of their mother, Mrs. Anna Lawton Scott
1982.9.2

This looking glass is closely related to
a group that can be associated with the
merchant William Wilmerding whose
New York shop advertised "a large and
elegant assortment of gilt and wooden
framed Looking Glasses and a variety of
other articles of the last importation."
Although many looking glasses were
imported in the eighteenth century, this
design is found most frequently in the
New York area. The presence of red
spruce (*Picea rubens*—a northeastern
conifer characteristic of the mountain-
ous regions of northern New York and
New England) may indicate American
manufacture.

SIDE CHAIR
Attributed to James Gillingham, 1736–1781
American, Philadelphia, ca. 1770
Mahogany, 38½ × 23 × 16½ in. (97.8 × 58.4 × 42 cm)
Gift of Martha and William Steen in memory of their mothers,
Katharine B. Merrifield and Nora T. Steen
1982.43

The design for this chair is illustrated as plate X in the third edition
of Thomas Chippendale's *The Gentleman and Cabinet-maker's Director*,
printed in London in 1762. Restrained sophistication in the adaptation of
that design, quality of craftsmanship, and crisp execution of carved detail
manifest the mature achievement of American cabinet and chair makers in
the period immediately preceding Independence. This chair is one of four
from a larger set published in 1901 by Luke Vincent Lockwood. One of
those chairs retained the label of its maker: "James Gillingham, cabinet
and chair maker in Second Street, between Walnut and Chestnut Streets,
Philadelphia."

HIGH CHEST OF DRAWERS
American, Philadelphia, ca. 1780
Mahogany, with pine and poplar;
H. 91 in. (231 cm)
Gift of Mr. and Mrs. Robert A. Magowan
77.2

The remarkable high chests of drawers
produced by Philadelphia cabinetmakers
and carvers mirror the self-confidence,
sophisticated taste, and mature accom-
plishment of that city's artisans and
patrons in the period immediately before
and after the American Revolution. Char-
acterized by highly figured and richly
grained woods, crisp carving, and elegant
proportions, they rank among the finest

examples of American cabinetwork of
the eighteenth century.

Usually made *en suite* with a dressing
table, these high chests retained the
basic form of their Queen Anne antece-
dents, but the selective incorporation of
elements of the rococo, which Chippen-
dale called the "modern" style, resulted
in a distinctive American expression that
had no parallel in English furniture.

Traditionally known as "Bathsheba
Hartley's high chest," this piece was
made for Benjamin Hartley. His daughter
Bathsheba married John Brick in 1789,
and the chest descended in the Brick-
Deacon family.

**TALL CASE CLOCK**
Clock movement by Jacob Eby,
working 1803–1828
American, Manheim, Pennsylvania,
1810–1820
Mahogany, mahogany veneers,
and inlays of contrasting woods;
93¼ × 21⅝ × 11½ in. (237 × 55 × 29.2 cm)
Gift of Willard R. Dye in memory
of Grace Shelly Dye
1984.4

Characterized by its elegant proportions
and the use of an oval inlay based upon
the Great Seal of the United States, the
bow-fronted case of this clock is one of
an important group of clock cases that
have been traced to an as-yet-unidentified
Lancaster County cabinetmaker. Of this
group, most contain clock movements
signed by Jacob Eby, a member of a
prominent family of clockmakers who
worked at Manheim. Strategically located
in northwest Lancaster County, the town
of Manheim was on an important north-
south route and supported a thriving
community of highly skilled craftsmen
in disproportion to its population.

The clock descended in the family
of John and Barbara Hershey Shelly and
was acquired by them at some time after
their marriage in 1809 and before they
left Lancaster County in the mid 1820s
to relocate in Jefferson County, Ohio.

THOMAS EAKINS
American, 1883–1916
*An Arcadian*, 1883, cast 1900–1930
Bronze, H. 8¼ in. (21 cm)
Gift of Mr. and Mrs. John D.
Rockefeller 3rd
1979.7.36

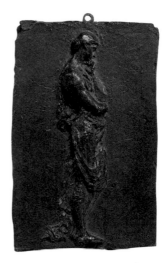

Arcadia, a paradise inhabited by a people
who lived in contented pastoral simplicity
in concert with nature, was a theme that
had fascinated artists and writers from the
time of the Greek poet Theocritus in the
third century B.C. In the 1880s Thomas
Eakins began exploring the Arcadian
theme in a series of photographs, paint-
ings, and relief sculptures. Best known
as a painter, Eakins had studied sculpture
with Augustine-Alexandre Dumont in
Paris and lectured on relief sculpture to
his students at the Pennsylvania Academy
of Fine Arts. Although many of his sculp-
tures have been considered studies for
paintings, he did produce a small but sig-
nificant group of works in that medium.
Thought to be a unique cast in bronze,
*An Arcadian* depicts one figure from a
procession of figures modeled for a larger
composition entitled *Arcadia*.

HERBERT HASELTINE
American, 1877–1962
*Suffolk Punch Stallion: Sudbourne Premier*,
1921–1924, cast 1937
Gilt bronze with lapis-lazuli, onyx, and
ivory; H. 22 in. (55.9 cm)
Mildred Anna Williams Collection
1937.10

Herbert Haseltine was born in Rome,
the son of the Philadelphia landscape
painter William Stanley Haseltine and
the nephew of the sculptor James Henry
Haseltine. Encouraged by his family, he
pursued a career in art with study in
Rome, at Harvard University, in Munich,
and in Paris. His success in modeling
equestrian subjects earned him both
acclaim and commissions. Haseltine
developed a personal style that was to
be fully realized in a series of portraits
of British champion animals, modeled
between 1921 and 1924. Originally cut in
various semi-precious stones, the series
was first shown in Paris in 1925. Versions
of this series were subsequently cast in
bronze. Sudbourne Premier was named
first and champion at the shows of the
Royal Agricultural Society of England
in 1921 and 1922.

TANKARD
Made by Paul Revere II, 1735–1818
American, Boston, 1760–1770
Silver, H. 9¼ in. (23.5 cm)
37 oz., 16 dwts
Museum Purchase, Art Trust Fund
78.24

Most widely known today for his role
as a colonial patriot, Paul Revere in his
day was noted for his craftsmanship as
a goldsmith and as a strong force in civic
and political affairs. He mastered his craft
in the shop of his father, Apollos Rivoire
(Paul Revere I), a French Huguenot who
had immigrated to Boston in 1716.

Rare among the surviving tankards
made by Revere, this example is unusu-
al both in its baluster shape and silver
weight. One other Revere tankard of this
form is known; both reflect the influence
of contemporary English silver of the
period. The cast silver mask on the tail-
piece of the handle depicts the head of
Bacchus, the Greek god of wine. The
Revere mark is struck twice on the tank-
ard, at the left of the handle and on the
underside of the base.

PRESENTATION PUNCH BOWL
Made by Hugh Wishart,
working 1784–1816
American, New York City, 1800
Silver, diam. 13½ in. (34.3 cm)
94 oz., 15 dwts
Engraving signed: *Rollinson Sculp.*
(William Rollinson, 1762–1842)
Museum purchase, the William
H. Noble Bequest Fund
1979.46

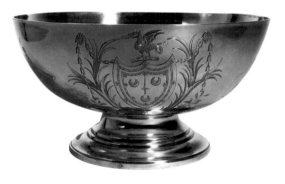

On 9 December 1800 the board of direc-
tors of the New York Insurance Company
unanimously resolved "that the thanks of
the Board be communicated to William
D. Seton, Esquire . . . and that a piece of
plate of the value of one hundred pounds
be presented to him. . . ." The execution
of that piece of plate was to combine the
considerable talents of two distinguished
New York craftsmen. The silversmith
Hugh Wishart wrought the hemispher-
ical bowl and the engraver William
Rollinson (who had been selected to
ornament the silver buttons for the
coat worn by George Washington at his
first inauguration) engraved an elaborate
cartouche. The cartouche contains the
inscription: *Presented by the President and
Directors of the New York Insurance Com-
pany to Captn Wm. D. Seton as testimony
of the high sense which they entertain of
his Gallant Conduct in Defending his Ship
the Northern Liberties against the French
Privateer Malartic of superior force in the
Bay of Bengal. 13. Decr. __1799.* On the
opposite side Rollinson engraved the
arms and crest of Captain Seton and on
either side of these devices, the encounter
and battle between the *Northern Liberties*
and the *Malartic.*

## SEAL BOX (SKIPPET)
American, Washington, D.C., 1845–1871
Silver, diam. 5 in. (12.7 cm), 17 oz.
Museum purchase, Art Trust Fund and
the Jane Clark Carey Bequest Fund
1983.37

The ancient practice of guaranteeing
agreements between governments with
an official seal was practiced in America
throughout the colonial period and con-
tinued after the United States secured its
independence. By the nineteenth century,
convention dictated that the official docu-
ments of international treaties and agree-
ments be bound in velvet portfolios with
metallic seal boxes, usually silver. The
seal box, or skippet, was suspended from
a document by bullion cords (woven
strands of gold or silver entwined with
silk) threaded through the sides of the
seal box as the document was bound.
The seal box was filled with hot wax to
receive the impression of the official seal,
and the lid of the box decorated with a
design based upon that seal. When in
place, the lid protected the fragile wax.

Usually unmarked, skippets are known
to have been made for the State Depart-
ment by the Georgetown silversmiths
Charles A. Burnett and Jacob Leonard,
and Seraphim Masi of Washington. Their
use by the United States government,
begun in 1815, was discontinued by
Secretary of State Hamilton Fish in 1871.
Seal boxes are rare unless attached to a
treaty; this skippet appears never to have
been used and may have served as a dip-
lomatic gift.

## TEAPOT
Made by S. Kirk and Son,
working 1846–1861
American, Baltimore, 1846
Silver, H. 7¾ in. (19.7 cm)
Gift of Mr. and Mrs. John B. Bunker
in memory of Mrs. Bunker's
great-grandmother, Emily Meigs Biddle
1984.42.6

This teapot is one of two in a coffee
and tea service. Each piece of the set is
engraved with the conjoined monogram
*EMWB* and the inscription *Gift of Mr.
and Mrs. Thomas Biddle to Emily S. Meigs
and J. William Biddle. Married April 16th
1846.* Repoussé flowers, foliage, birds,
and animals surround vignettes of fan-
ciful architecture and reserves for the
monograms. This type of decoration,
originated by Samuel Kirk and probably
derived from English Regency designs,
has become known as Baltimore Repoussé.
The service descended in Mrs. Bunker's
family and was presented to the Museums
on the reopening of the expanded Amer-
ican Galleries in 1984.

ONE OF FOUR CANDLESTICKS
Marked by Shreve and Company
American, San Francisco, 1917
Silver, H. 18½ in. (47 cm)
Gift of Mrs. Silas H. Palmer
1980.18.16

Four cast, chased, and repoussé candle-
sticks in the form of a Dutch iris are
the most remarkable objects in an out-
standing silver service of 307 pieces.
Assembled between 1907 and 1917, the
service is unified by the use of the iris as
its motif. Each piece is marked by the San
Francisco firm of Shreve and Company;
however, much of the flatware carries
the additional marks of the William B.
Durgin Company and the Gorham Manu-
facturing Company, which had acquired
Durgin. Founded ca. 1852 by George
Shreve, Shreve and Company was both
a retailer and manufacturer of silver and
produced at least twenty exclusive pat-
terns of flatware. Obviously handmade,

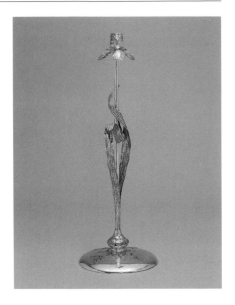

the candlesticks may have been crafted
by silversmiths in the Shreve workshop.
The underside of each candlestick is
inscribed: *Christmas 1917.*

BANK
Attributed to the Boston and
Sandwich Glass Company
American, Sandwich, Massachusetts,
ca. 1830
Free-blown glass, H. 10½ in. (26.7 cm)
Museum purchase, gift of the
Hillsborough Auxiliary
1986.19

Traditionally thought to have been made
as "off-hand" or "whimsy" objects, banks
of this type were made by glass-house
workmen from the glass melt that re-
mained at the end of a day's production.
Surviving examples are rare, as most of
these banks were destroyed in attempts
to retrieve their contents. The applied
rigaree decoration and the fanciful bird
finial indicate the facility of the glass
blower in handling the molten and fragile
medium of his craft.

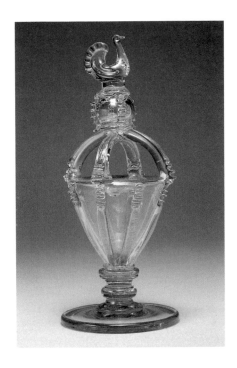

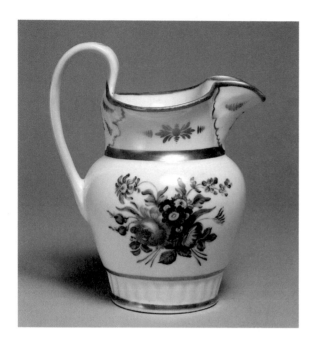

PITCHER
William Ellis Tucker, 1800–1832
Marked "F" (Charles Frederick,
a Tucker workman)
American, Philadelphia, ca. 1830
Porcelain, H. 9¼ in. (23.5 cm)
Museum purchase, Art Trust Fund
1981.31

Archeological evidence documents
ceramic production in America as early
as the seventeenth century. However,
these early potters produced mainly util-
itarian earthenwares. Attempts to manu-
facture fine porcelain in America were
rare, and the potteries that succeeded
found themselves unable to compete in
a market that preferred the design, qual-
ity, and lower cost of imported European
and Oriental china. Undeterred, William

Ellis Tucker, son of a Philadelphia mer-
chant who dealt in imported ceramics,
began to experiment with porcelain. By
October 1826 he had developed a for-
mula for its production. Two years later
the wares he exhibited at the Franklin
Institute were judged the best being made
in America, comparable to the finest
French china.

Though never a financial success,
the significant production of the Tucker
venture presaged the development of an
American ceramic industry in the nine-
teenth century.

The gilt decoration and the overglaze
floral painting are typical of Tucker
porcelains. The initials *LLJ (LLT)* that
appear on the body of this pitcher are
those of the original owner.

WALLPAPER (detail)
*Les Voyages du Capitaine Cook*
Also called *Les sauvages de la mer du Pacifique*
Designed by Jean Gabriel Charvet, 1750–1829
Printed by Joseph Dufour, 1742–1827
French, Mâcon, ca. 1806
Block-printed on paper, each panel 99 × 21 ¼ in. (251.5 × 54 cm)
Gift of Georgia M. Worthington and The Fine Arts Museums Trustees Fund
77.6

Among the rarest of the remarkable French scenic wallpapers, *The Voyages of Captain Cook* was the first "decorative picture in a wall-paper" produced by the firm of Joseph Dufour. The panoramic composition presents a romantic, European vision of some of the islands visited by Captain James Cook. His voyages of exploration to the Pacific in the 1770s were popularized by the publication of his journals and their accompanying engravings. Promoted by Dufour as historically accurate and educational, the paper was accompanied by a printed brochure that described the places and events depicted in each of the twenty panels.

Scenic wallpaper was both popular and available in America during the Federal period of the early nineteenth century and decorated houses from Maine to New Orleans. Installed for the first time in the American Galleries, this set of *The Voyages of Captain Cook* is remarkable in its survival as full, untrimmed sheets and the retention of the original brilliant colors. Of the twenty panels that comprise the set, two are modern reproductions.

*TREE OF LIFE* WINDOW
Designed by Frank Lloyd Wright,
1869–1959
American, executed by the Linden
Glass Company, Chicago, Illinois, 1904
Clear, colored, and iridescent glass
with copper-coated zinc caming;
47½ × 32⅜ in. (120.7 × 82.2 cm)
Gift of Mrs. Darwin Martin
1982.70

Considered Wright's finest window from
his Prairie School period, the *Tree of Life*
windows were installed in the remark-
able complex of buildings designed as
the residence of D. D. Martin and con-
structed in Buffalo, New York, in 1904.
In this complex, which encompassed

a main house, greenhouse, garage, and
a smaller house for Martin's sister and
brother-in-law, Wright achieved one of
his most unified and harmonious proj-
ects. Martin, an executive of the Larkin
Soap Company, for which Wright also
designed the company administration
building, was a lifelong friend. He al-
lowed the architect total freedom in the
project. In addition to the windows
Wright also designed the furniture,
lighting fixtures, and table lamps, and
advised the Martins in the collection of
Japanese prints and ceramics for display
in the house. The geometric abstraction
of the tree motif visually integrated the
architectural forms of the house with
the natural environment of its site.

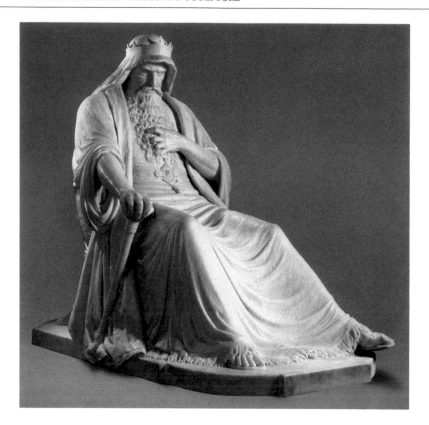

WILLIAM WETMORE STORY
American, 1819–1895
*King Saul*, 1882
Marble, H. 57 in. (144.8 cm)
Gift of M. H. de Young
49622

The son of a distinguished law professor and associate justice of the United States Supreme Court, William Wetmore Story studied law before pursuing a career as a sculptor. Financially independent, he settled permanently in Rome where his apartment became a gathering place for artistic and literary luminaries of his day, and he gained international recognition for his large figures executed in marble. A literary romanticist, Story was influenced by themes of antiquity and the neoclassical tradition of Rome, his subjects deriving from literature, history, and mythology.

Saul, son of Kish of the tribe of Benjamin and first king of Israel, is represented here at the moment described in I Samuel 16:14: "Now the Spirit of the Lord departed from Saul, and an evil spirit from the Lord tormented him." Story first modeled this subject in 1862. In a second version he replaced a knife with a great staff in the right hand. This marble is one of two copies of that version cut in 1882.

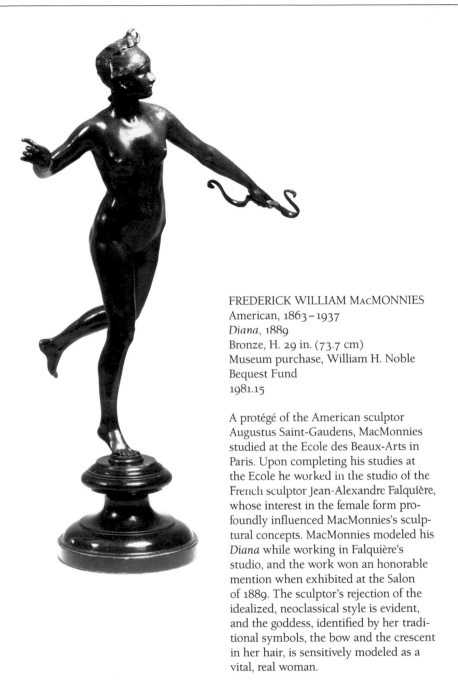

FREDERICK WILLIAM MacMONNIES
American, 1863–1937
*Diana*, 1889
Bronze, H. 29 in. (73.7 cm)
Museum purchase, William H. Noble
Bequest Fund
1981.15

A protégé of the American sculptor
Augustus Saint-Gaudens, MacMonnies
studied at the Ecole des Beaux-Arts in
Paris. Upon completing his studies at
the Ecole he worked in the studio of the
French sculptor Jean-Alexandre Falquière,
whose interest in the female form pro-
foundly influenced MacMonnies's sculp-
tural concepts. MacMonnies modeled his
*Diana* while working in Falquière's
studio, and the work won an honorable
mention when exhibited at the Salon
of 1889. The sculptor's rejection of the
idealized, neoclassical style is evident,
and the goddess, identified by her tradi-
tional symbols, the bow and the crescent
in her hair, is sensitively modeled as a
vital, real woman.

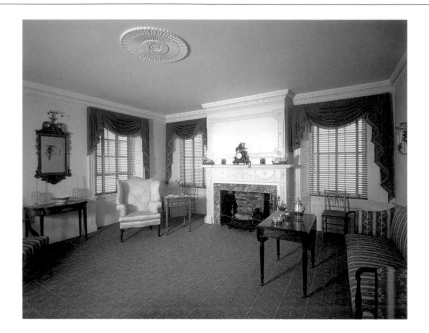

## FEDERAL PARLOR
Architectural elements from the left front parlor, no. 5 Harris Street
American, Newburyport, Massachusetts, 1805
Acquisition and installation, gift of The Museum Society Auxiliary
77.15

In 1805 Leonard Smith began construction of two houses on the corner of
Harris and Green Streets in Newburyport, Massachusetts. Built for his two
sons, the houses were virtually identical: solid masonry construction with
hipped roofs and a central hall plan of four rooms on each of their three
stories. In design and detail these houses were typical of the fine Federal-
style houses built in Newburyport between 1800 and 1812.

In 1937 the house at no. 5 Harris Street was sold for demolition. In report-
ing its destruction the *Newburyport Daily News* observed, "As workmen tore
it down, examples of some of the finest carved woodwork in this city came
to view. Adam period carvings around some of its fireplaces were excep-
tionally good." Fortunately the woodwork and fireplace from the left front
parlor were salvaged by Mrs. Harry Horton Benkard, a pioneer collector
of American decorative arts, and they were for a time installed in her home
at Oyster Bay, New York.

Acquired by The Fine Arts Museums in 1977, the room was installed in
the new American Galleries as an environmental setting for the display of
decorative arts of the Federal period. Refurbished in 1984, the room now
contains many objects from the Benkard collection that were given by Mrs.
Benkard's daughter, Mrs. Reginald P. Rose, or that were included in the
Benkard-Rose Collection given in honor of their mother and grandmother
by George and R. Peter Rose.

# AMERICAN
# PAINTINGS

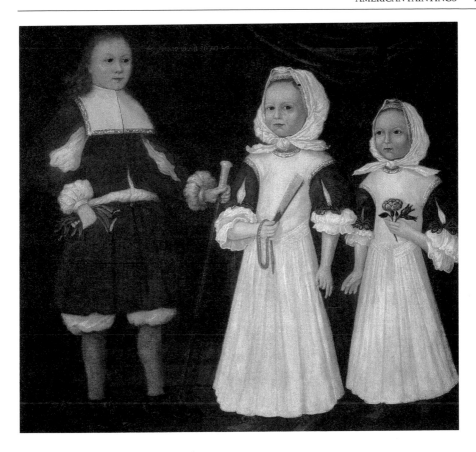

Attributed to the FREAKE-GIBBS PAINTER
American, active in Massachusetts, 1670
*The Mason Children: David, Joanna, and Abigail*, 1670
Oil on canvas, 39½ × 42¾ in. (100.3 × 108.6 cm)
Inscribed and dated across the top: *8 Anno Dom. 1670 6 4*
Gift of Mr. and Mrs. John D. Rockefeller 3rd
1979.7.3

Among the most complex and captivating of seventeenth-century Amer-
ican artifacts, *The Mason Children* is the earliest American painting in the
Museums' collection. It is a portrait of three of the children of Arthur and
Joanna Parker Mason, prominent Boston residents. The unknown artist was
a talented portraitist in the English provincial style, continuing the linear,
geometric traditions of Elizabethan and Jacobean painting. Using small
brushstrokes and slight color gradations, he characterized the children as
fashionable adults, giving them attributes of wealth and status. Lace, coral
beads, kid gloves, and silver-handled walking stick, all handsomely detailed,
testify to the success of Boston's mercantile class and belie the romantic
notion of an exclusively somber Puritan life.

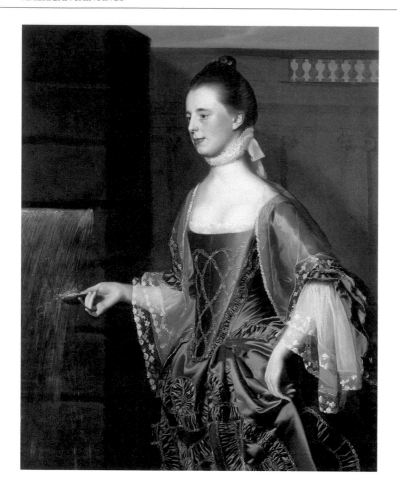

JOHN SINGLETON COPLEY
American, 1738–1815
*Mrs. Daniel Sargent (Mary Turner Sargent)*, 1763
Oil on canvas, 50 × 40 in. (127 × 101.6 cm)
Signed and dated lower left: *John Singleton Copley / Pinx 1763*
Gift of Mr. and Mrs. John D. Rockefeller 3rd
1979.7.31

Copley is widely regarded as America's first native painter of genius. He
painted Mary Turner, granddaughter of the Salem merchant who built the
House of Seven Gables, in his early maturity, perhaps to commemorate the
sitter's marriage in 1763 to Daniel Sargent. The work is an elegant example
of the largely self-taught artist's ability to reproduce the elaborate effects
of light playing on differing surfaces. The sitter later bore witness to the
artist's painstaking technique, telling her son, the artist Henry Sargent
(who reported it in turn to the early art historian William Dunlap), that
she had "sat to him fifteen or sixteen times! Six hours at a time!!"

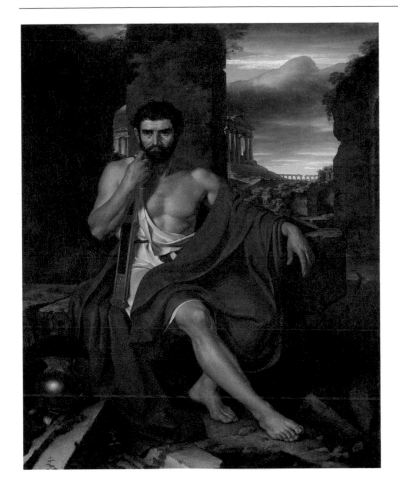

JOHN VANDERLYN
American, 1775–1852
*Marius Amidst the Ruins of Carthage*, 1807
Oil on canvas, 87 × 68½ in.
(220.9 × 174 cm)
Signed and dated lower right:
*J. Vanderlyn / Roma 1807*
Gift of M. H. de Young
49835

The winner of a gold medal at the 1808 Paris Salon, Vanderlyn's *Marius*, by virtue of its scale, treatment, and subject (which is taken from Plutarch's account of the second-century-B.C. Roman consul Caius Marius), signals the increasing ambition of the American artist. Sent by his patron, Aaron Burr, for study in Paris and Rome, Vanderlyn hoped to foster the development of history painting in the American republic. Refusing the opportunity to sell the work in France, the artist exhibited this and other monumental paintings extensively from New York to Havana. Unfortunately, Vanderlyn failed to spark the enlightened patronage that he had hoped to inspire. In 1834 he finally sold *Marius* to Leonard Kip, his neighbor in Kingston, New York. The painting traveled to California in 1857 with the household effects of Kip's son, Canon William Ingraham Kip, later first Episcopal bishop of the state.

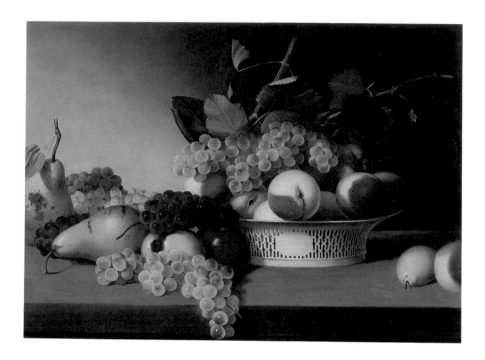

JAMES PEALE
American, 1749–1831
*Still Life with Fruit*, ca. 1821
Oil on panel, 18¾ × 25¾ in. (47.6 × 65.4 cm)
Museum purchase
46.11

James Peale, the younger brother of Charles Willson Peale, painted mini-
atures, portraits, landscapes, and history paintings over the course of his
long career. When he was in his seventies, and his eyesight was weakening,
he turned instead to still-life painting; along with his nephew Raphaelle he
was one of the first Americans to practice the form. *Still Life with Fruit* is one of
three closely related works (the others are in The Pennsylvania Academy of
the Fine Arts and a private collection) that recreate an elegant and believable
illusion through virtually invisible brushwork and minute color gradations.
Reflecting in its formal arrangements the calm and order of a neoclassical
sensibility, the painting's handsome porcelain bowl and profusion of fresh
fruit appear to display a determined optimism regarding the trade and agri-
culture of the young republic. The bruised pears and torn grape boughs,
however, might well reflect the more personal concerns of an elderly artist's
response to his own mortality.

GEORGE CALEB BINGHAM
American, 1811–1879
*Boatmen on the Missouri*, 1846
Oil on canvas, 25 × 30 in. (63.5 × 76.2 cm)
Gift of Mr. and Mrs. John D. Rockefeller 3rd
1979.7.15

Among the first of Bingham's celebrations of Missouri river life, *Boatmen on the Missouri* shows three raftsmen resting from their task of selling wood to passing steamboats. The figures, statuesque with massive limbs and direct gazes, are grouped as a solid pyramid pinned into place by the oars that touch both edges of the picture. Although Bingham has painted the raftsmen broadly with patches of strong colors, he has used the most delicate gradations of pastel shades to evoke the quiet landscape wrapped in early morning mists. *Boatmen on the Missouri*, one of the earliest views of daily life on the western frontier to find a popular audience on the East Coast, was a prize in New York's American Art-Union lottery of 1846. Sent to the winner in New Orleans, the painting was lost to public view for 120 years until its widely heralded discovery in a California private collection in 1966.

WINSLOW HOMER
American, 1836–1910
*The Bright Side*, 1865
Oil on canvas, 13 × 17½ in. (33 × 44.5 cm)
Signed, dated, and inscribed lower left: *Winslow Homer NY-65*
Gift of Mr. and Mrs. John D. Rockefeller 3rd
1979.7.56

Homer went south in 1861 on the first of probably three assignments to cover the Civil War as an artist-correspondent for the popular magazine *Harper's Weekly*. Generally avoiding the more active drama of the battle, he recorded the realities of life in the Union camps, sketching a series of views that would later provide him with material for his earliest oil paintings. In one of the finest of these, *The Bright Side*, four black teamsters relax in the sun while a fifth pokes his head out from their tent. The work, which is thinly painted, demonstrates Homer's keen eye for natural poses and vivid atmosphere. The punning title works on several levels, recording not only the men's position on the sunny side of the tent, but as well suggesting the relative ease of their responsibilities for the northern, "brighter" side of the war.

EASTMAN JOHNSON
American, 1824–1906
*The Pension Claim Agent*, 1867
Oil on canvas, 25¼ × 37⅜ in. (64.1 × 94.9 cm)
Signed and dated lower right: *E. Johnson. 1867*
Mildred Anna Williams Collection
1943.6

Eastman Johnson, although trained in Germany, France, and the Nether-
lands, was hailed in the nineteenth century as the most American of artists.
His portraits and genre works, whether vividly sketched or carefully fin-
ished, function as windows opening on Victorian America. *The Pension
Claim Agent* recreates a scene common in the years following the Civil War:
a government official has traveled to the home of a wounded veteran to ver-
ify pension and disability claims. Surrounded by his family in the simple
country kitchen, the one-legged veteran recounts his history. Johnson's thinly
applied, monochromatic colors seem appropriate to the blighted life he por-
trays, epitomized by the chill winter visible through the window.

FREDERIC EDWIN CHURCH
American, 1826–1900
*Rainy Season in the Tropics*, 1866
Oil on canvas, 56¼ × 84⅛ in. (142.9 × 213.7 cm)
Signed and dated lower right: *F. E. Church / 1866*,
and lower left: *F. E. Church / 1866*
Mildred Anna Williams Collection
1970.9

Frederic Church's vast landscape panoramas were among the most cele-
brated paintings of the nineteenth century. The large, romantic compositions
of tropical and arctic scenery (often based on broadly worked, luminous
sketches) were frequently exhibited in specially lit spaces where their minute
detail and convincing atmosphere could mentally transport the viewer to
the distant land portrayed. *Rainy Season in the Tropics*, one of the last of his
grand tropical works, is a complex blend of naturalism and fantasy. In spite
of the wholly convincing unity of the atmosphere, the splendid landscape
appears to merge a distant view of the Ecuadorean Andes with the rocky
outcroppings characteristic of the Jamaican highlands. The sparkling double
rainbow, symbol of promise and benevolence, adds a celebratory element
to the picture.

ALBERT BIERSTADT
American, 1830–1902
*View of Donner Lake, California,*
1871 or 1872
Oil on paper, 29 × 21¼ in. (73.7 × 54 cm)
Signed lower left: *ABierstadt*
Gift of Anna Bennett and Jessie Jonas
in memory of August F. Jonas, Jr.
1984.54

In the luminous *View of Donner Lake,*
Bierstadt faces the mist-enshrouded sun
rising over the Sierra Nevadas. This freely
and thinly painted work is a finished
study for the large panoramic view (now
in the New-York Historical Society) com-
missioned by Collis P. Huntington to
commemorate the highest and most dif-
ficult stretch encountered in the building
of his Central Pacific Railroad. On one
level the work celebrates the opening
of the continent—the trestles and snow-
sheds of Huntington's engineers, forcing
a passage through the very landscape
where the 1846 Donner Party met its
tragic fate, have brought nature under the
sway of man. But on another level, with
its radiant light and precipitous aspect,
Bierstadt has romanticized and ennobled
this view of the California landscape.

THOMAS EAKINS
American, 1844–1916
*The Courtship*, ca. 1878
Oil on canvas, 20 × 24 in. (50.8 × 61 cm)
Signed center right, on base of spinning wheel: *-kins*
Gift of Mrs. Herbert Fleishhacker, M. H. de Young, John McLaughlin,
J. S. Morgan and Sons, and Miss Keith Wakeman, by exchange
72.7

Thomas Eakins, painter, photographer, and teacher, is best known for the
carefully observed portraits and outdoor genre scenes in which he sought
to record the physical appearance of the natural world. Following the 1876
Centennial International Exhibition in Philadelphia, however, he executed
a series of more imaginative, historical scenes evocative of the eighteenth or
early nineteenth century. *The Courtship* is one of these; with its golden light
and air of psychological absorption, it seems to reflect a nostalgia for the
simplicity of a pre-industrial national past. Nonetheless, Eakins's sensitivity
to pose, glance, and gesture suggests the forceful characterization and close
study for which he is so well known.

THOMAS P. ANSHUTZ
American, 1851–1912
*The Ironworkers' Noontime*, ca. 1881
Oil on canvas, 17⅛ × 24 in. (43.5 × 61 cm)
Signed lower left: *Thos. Anshutz*
Gift of Mr. and Mrs. John D. Rockefeller 3rd
1979.7.4

Despite the increasing urbanization of American life after the Civil War, few
painters of the later nineteenth century were willing to take the unromantic
facts of industrialization as subjects for their art. One exception was Thomas
Anshutz, a student of Thomas Eakins and later his successor as instructor
at The Pennsylvania Academy of the Fine Arts. In his painting of iron-
foundry workers taking a noonday break, the figures form a frieze-like
band across the center of the canvas, their various postures and actions
revealing Anshutz's intimate knowledge of anatomy and his mastery of
composition. Calm, dignified even in their most mundane activities, these
workers convey a monumentality that belies the painting's small size.

MARY CASSATT
American, 1844–1926
*Mrs. Robert S. Cassatt, the Artist's Mother (Katherine Johnston Cassatt)*, ca. 1889
Oil on canvas, 38 × 27 in.
(96.5 × 68.6 cm)
Museum purchase, William H. Noble Bequest Fund
1979.35

Several times during her long and successful career, Mary Cassatt painted her mother, turning on her the same loving yet scrutinizing eye she employed in her sensitive, unsentimental depictions of mothers and children. The Museums'

portrait is the last of these paintings (although Cassatt made an etching of the same scene) and shows Mrs. Cassatt at about the age of seventy-three. Short, delicate strokes define the sitter's face and hands; the details of shawl, flowers, and background are brushed in with broad strokes of color that contrast with the rich, deep black of her dress. Recalling Edouard Manet and the milieu of French impressionism in which Cassatt thrived, the bold execution counters the reserve of Mrs. Cassatt's reflective pose, and suggests the vitality and intelligence of this dignified woman.

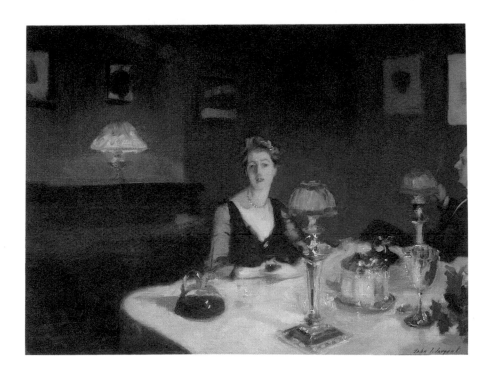

JOHN SINGER SARGENT
American, 1856–1925
*A Dinner Table at Night (The Glass of Claret)*, 1884
Oil on canvas, 20¼ × 26¼ in. (51.4 × 66.7 cm)
Signed lower right: *John S. Sargent*
Gift of the Atholl McBean Foundation
73.12

Born to American parents resident in Florence, Sargent went to schools
in Italy and Germany, studied painting in France, and, although he always
retained his American citizenship, lived from the mid-1880s principally
in England. Among his earliest English patrons were Mr. and Mrs. Albert
Vickers, portrayed in *A Dinner Table at Night* in their dining room at Lav-
ington Rectory, near Petworth. Using glazes of rich color and artfully placed
touches of thickly impastoed paint—the latter particularly effective in cre-
ating the illusion of silver and glassware—the artist's summary technique
and eccentric framing here provide an intimate, informal portrait of elegance
and distinction.

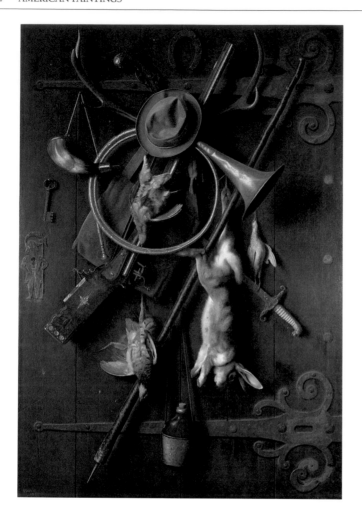

WILLIAM MICHAEL HARNETT
American, 1848–1892
*After the Hunt*, 1885
Oil on canvas, 71½ × 48½ in.
(181.6 × 123.2 cm)
Signed and dated lower left:
*WM Harnett / 1885* (WMH in monogram)
Mildred Anna Williams Collection
1940.93

Harnett, the best-known American nine-teenth-century practitioner of trompe l'oeil (or trick-the-eye realism), painted four versions of *After the Hunt*. Basing these works in part upon nineteenth-century German photographs, he por-trayed the weapons and devices of the hunt hanging alongside the day's trophies on a cracked and peeling door. Meticu-lously concealing all evidence of his brushwork, the artist has created within this shallow space a masculine world of richly textured objects that challenge the viewers' discrimination of illusion and reality. After the successful exhibition of this last and largest of the series at the 1885 Paris Salon, the painting hung for over thirty years in a popular New York saloon.

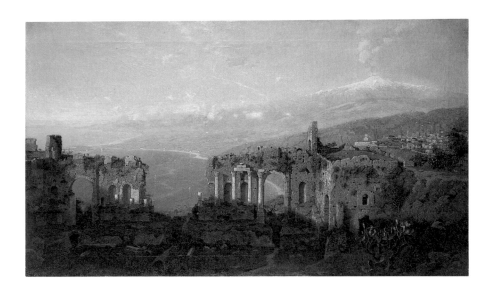

WILLIAM STANLEY HASELTINE
American, 1835–1900
*Ruins of the Roman Theatre at Taormina, Sicily*, 1889
Oil on canvas, 32⅝ × 56½ in. (82.9 × 143.5 cm)
Signed, dated, and inscribed lower left: *W. S. Haseltine. / Rome 1889*
Gift of Peter McBean
1986.41

Although William Stanley Haseltine is best known for the detailed views
of New England coastal scenery that he painted in the early 1860s, he lived
for nearly thirty years in Rome at the center of the Anglo-American expatri-
ate colony. One of the Italian views that Haseltine returned to repeatedly over
these years was Mount Etna as seen from the ruins of Taormina, Sicily. In
this version of the scene the artist's mastery of complex effects of light and
air holds both the majesty of Etna and the romanticism of the ruins in bal-
ance, centering attention on the atmospheric whole.

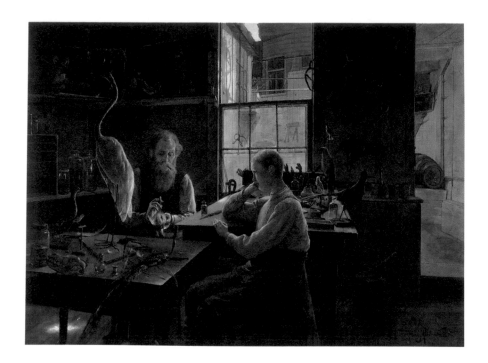

HENRY ALEXANDER
American, 1860–1895
*The First Lesson*, ca. 1890
Oil on canvas, 25 × 34 in. (63.5 × 86.4 cm)
Signed lower right: *Henry Alexander*
Mildred Anna Williams Collection
1952.76

Trained in Munich, Alexander developed a precise and detailed style appropriate to his fascination with the clutter of Victorian laboratory, shop, and parlor interiors. *The First Lesson* shows a darkened taxidermy shop; at the center a young apprentice watches his master slit the belly of a meadowlark. Light streams through the window, spilling into a thickly painted pool and casting an eerie glow around the edges of objects and figures. The careful attention that Alexander pays to each element of this composition lends a luminous, but unsettling, consistency to the painting, blurring the distinction between the animate figures and the supposedly stilled life around them. This painting is one of the relatively few works remaining from Alexander's short career; many of his paintings, gathered together by his family in San Francisco, were destroyed during the earthquake and fire of 1906.

JOHN FREDERICK PETO
American, 1854–1907
*Job Lot Cheap*, ca. 1900
Oil on canvas, 30 × 40⅛ in. (76.2 × 101.9 cm)
Signed lower right: *J. F. Peto*
Gift of Mr. and Mrs. John D. Rockefeller 3rd
1979.7.81

Born and trained in Philadelphia, in 1889 Peto moved to the religious community of Island Heights, New Jersey, where he supported himself and his family by playing cornet in the community band. Painting largely in the trompe l'oeil manner of his better-known colleague William Michael Harnett, Peto gradually developed a softened, seemingly melancholic style that featured abandoned remnants of human activity such as worn books, torn signs, and forgotten string. In *Job Lot Cheap* he combines a standard trompe l'oeil setting—a flat, vertical surface parallel to the picture plane—with the greater recession implied by the jumble of books seen through the open window. The cropped notices attached to the wooden shutter and frame, "JOB LOT CHEAP," and "DEALER IN BOOKS," offer the explanation for this collection of discarded volumes.

WILLIAM GLACKENS
American, 1870–1938
*Maypole, Central Park*, 1905
Oil on canvas, 25⅛ × 30¼ in. (63.8 × 76.8 cm)
Signed lower right: *W. Glackens*
Gift of the Charles E. Merrill Trust with matching
funds from The de Young Museum Society
70.11

A realist at odds with turn-of-the-century artistic conventions, Glackens
used his dashing brushstroke and rich color to capture in *Maypole, Central
Park* the rowdy hubbub of a springtime celebration in New York. In this
painting, well-dressed children wrestle and play in the sunlight while the
maypole teeters in the shade, largely ignored. The artist, who like several
other members of "The Eight" worked as a newspaper illustrator, conveyed
the vitality of the scene by combining the simplifications of caricature with
apparently spontaneous poses.

GRANT WOOD
American, 1891 – 1942
*Dinner for Threshers*, 1934
Oil on masonite, 19½ × 79½ in. (49.5 × 201.9 cm)
Signed and dated lower left: *Grant Wood / 1934* ©
Gift of Mr. and Mrs. John D. Rockefeller 3rd
1979.7.105

A leading exponent of regionalism, Grant Wood worked in a plain style
(based in part on Netherlandish and Italian fifteenth-century paintings)
on subjects inspired by his childhood in rural Iowa. One of many works
depicting his family and friends, *Dinner for Threshers* represents a popular
country social event—the mealtime gathering of farmer and crew occa-
sioned by the annual harvest. The painting's clarity of contour, meticulous
detailing of patterns, and repetition of geometric forms create a decorative
surface design characteristic of Wood's mature work. At the same time, the
monumental figures and the solemnity of the common meal, joined with
the religious associations of the triptych format, underscore the dignity of
American midwestern life.

THOMAS HART BENTON
American, 1889–1975
*Susanna and the Elders*, 1938
Tempera and oil on canvas mounted on
panel, 60⅛ × 42⅛ in. (152.7 × 107 cm)
Signed lower right: *Benton*
Anonymous gift
1940.104

The subject of Benton's *Susanna and the
Elders* is taken from the Apocryphal Book
of Daniel in which two respected mem-
bers of the community steal up on the
virtuous Susanna and proposition her
while she is at her bath. Enraged at her
refusal, they falsely charge her with adul-
tery. Only the wisdom of the prophet

Daniel, who separates the two men and
discovers discrepancies in their perjured
testimony, saves Susanna from an unjust
death. As a regionalist painter seeking
to work from the world around him,
Benton has updated the scene and shifted
the locale from Babylon to the Ozarks.
Perhaps in part because of this applica-
tion of the biblical tale to modern times,
and certainly because of the bold nudity
of the almost mannerist figure, *Susanna
and the Elders* caused a sensation when
the work was exhibited throughout the
Midwest and West in 1938 and 1939.

# PRINTS
# AND DRAWINGS

WORKSHOP OF PETER BRUEGHEL THE ELDER
Flemish, ca. 1528–1569
*The Beekeepers*
Pen and brown ink on laid paper, 8⅛ × 12½ in. (206 × 316 mm)
Inscribed lower left: *dije den nest Weet dije Weeten dijen Rooft*
*dij heeten,* and lower right: *P.BR.156(7)*
Achenbach Foundation for Graphic Arts purchase
and William H. Noble Bequest Fund
1978.2.31

On the edge of a village, three beekeepers in protective clothing arrange
beehives while a boy climbs a tree. The scene is clarified by the inscription,
translated as "He who knows the nest, knows it; he who robs the nest has
it," a Netherlandish proverb meaning that the active man gets the profit.
A painting by Brueghel of 1568, *The Peasant and the Birdnester* (Kunsthis-
torisches Museum, Vienna) illustrates the same proverb but shows the boy
actually robbing a nest.

Brueghel's own drawing for *The Beekeepers* is in the collection of the Kup-
ferstichkabinett, Berlin, and another workshop copy, probably of a later date,
is in the British Museum. The Fine Arts Museums' drawing is also a work-
shop copy, possibly designed as a model for an engraving.

GIOVANNI FRANCESCO BARBIERI,
called IL GUERCINO
Italian, 1591–1666
*Saint John the Evangelist Meditating
the Gospel,* ca. 1645–1650
Pen and brown ink on laid paper,
8¾ × 7⅞ in. (222 × 200 mm)
Inscribed on scroll at lower left:
*IN PRINCIPIO ERAT VERBVM,*
and upper right: *10.P*
Achenbach Foundation for
Graphic Arts purchase
1976.2.19

Giovanni Francesco Barbieri, known as
Il Guercino ("the squint-eyed"), was a
successful and unusually prolific Bolo-
gnese painter of the baroque period. He
was continually employed by ecclesiasti-
cal and private patrons throughout Italy,
and his drawings have always been prized
by great collectors and artists as well.

In this drawing, Saint John meditates
on his gospel passage *in principio erat
verbum* ("in the beginning was the
word"). Guercino accorded his subject
a genteel rendering in which lines, and
occasionally dots, create smooth tran-
sitions from light to deep shadow.

GIOVANNI ANTONIO CANAL,
called IL CANALETTO
Italian, 1697–1769
*View of the Arch of Constantine and
Environs, Rome,* late 1750s or early 1760s
Pen and brown ink with gray wash over
traces of graphite underdrawing on laid
paper, 8 × 12½ in. (203 × 316 mm)
On verso in graphite:
*an architectural sketch*
Roscoe and Margaret Oakes Fund and
Achenbach Foundation for Graphic
Arts purchase
1984.2.9 r–v

Canaletto's reputation and fame are asso-
ciated primarily with views of Venice
and London, but he probably began his
celebrated career as a painter of *vedute*
(views or townscapes) in Rome in 1719.
This drawing, however, dates from a
later period and reveals Canaletto's
mature technique and style in which
he juxtaposed brown ink lines and pas-
sages of gray wash to achieve the illusion
of topographic detail and a sense of bril-
liant light.

JEAN-HONORÉ FRAGONARD
French, 1732–1806
*Artist in the Studio,* ca. 1774
Red chalk on laid paper, 15⅛ × 19⅛ in. (382 × 486 mm)
Inscribed on mount lower left: *Boucher dans la Prison de
St.-Lazare,* and lower right: *B*
Achenbach Foundation for Graphic Arts purchase
1975.2.13

No artist better represented the extravagance and frivolity of the Parisian
demimonde at the end of the eighteenth century than Fragonard. However,
the subject of our drawing, which is now identified as the artist and his wife
in the studio, differs from his usual preference for park scenes, mythological
stories, and upper-class flirtations. Fragonard has movingly conveyed a scene
of unselfconscious domestic tranquility, imbued with warm human feeling
and a mood of relaxed intimacy. The revelation of self in this drawing is
unexpected in an artist best known for his artifice.

WILLIAM BLAKE
English, 1757–1827
*The Complaint of Job,* ca. 1786
Gray wash on thin wove paper, 12¾ × 18⅞ in. (324 × 480 mm)
Memorial gift from Dr. T. Edward and Tullah Hanley, Bradford, Pennsylvania
69.30.215

The Book of Job was for Blake a source of pictorial inspiration throughout his career. The subject for this drawing was taken from the Book of Job 7:17–18 in which Job, after losing his children and his possessions, and then suffering an attack of boils, asks God for justification: "What is man that thou . . . dost test him every moment?" Later in the 1790s Blake made an engraving in two states using this identical subject. It seems likely that the Museums' drawing may have been its basis. In 1825, almost thirty years after *The Complaint of Job* was made, Blake returned to this theme with his *Illustrations of the Book of Job,* a series of twenty-one engravings commissioned by John Linnell in 1823.

JOSEPH MALLORD WILLIAM TURNER
English, 1775–1851
*View of Kenilworth Castle,* ca. 1830
Watercolor and gouache on wove paper,
11½ × 17⅞ in. (292 × 454 mm)
Gift of Osgood Hooker
1967.4

The castle-fortress of Kenilworth, left in ruins by Oliver Cromwell's troops
in the seventeenth century, was the setting for Sir Walter Scott's 1821 novel
of the same name. In the tradition of nineteenth-century romantic artists,
Turner bestows an aura of grandeur on this already imposing ruin by
bathing it in light and atmosphere. He created this effect with passages of
glazing, drybrush, scraping, and stippling. An engraving after this water-
color was published in 1832 for Charles Heath's *Picturesque Views in England
and Wales.*

GEORGES PIERRE SEURAT
French, 1859–1891
*Study for "La parade de cirque,"* ca. 1887
Black crayon on laid paper, 9⅛ × 12⅛ in.
(233 × 308 mm)
Archer M. Huntington Fund
1947.1

Georges Seurat's drawings stand on their own among the significant artistic
achievements of the late nineteenth century. His friend Paul Signac called
them "the most beautiful painter's drawings that ever existed." In this
drawing Seurat has reduced his composition of clowns on a stage to the
barest essentials, concentrating instead on tonality and the interplay of
structure. The work is one from a series of similar studies that Seurat made
for the painting *La parade* (1888), now in The Metropolitan Museum of Art,
New York.

PAUL GAUGUIN
French, 1848–1903
*L'arlésienne, Mme Ginoux*, 1888
Colored chalks and charcoal with white
chalk heightening on wove paper,
22⅛ × 19⅜ in. (561 × 492 mm)
Inscribed upper right: *L'oeil moins a
costé du / nez / arête vive / à la naissance*
Memorial gift from Dr. T. Edward and
Tullah Hanley, Bradford, Pennsylvania
69.30.78

This monumental drawing and the paint-
ings by both Gauguin and Vincent van
Gogh that were inspired by it are re-
minders of the interplay that occurred
between these two artists.

Gauguin made this drawing during his
stay at Arles in the fall of 1888. Gauguin
was impressed by van Gogh's recently
completed painting *The Night Café* and
painted his own version of the scene with
the looming figure of a woman domi-
nating the foreground. Mme Ginoux,
wife of the owner of the café, posed for
this drawing which served as a prepara-
tory study for Gauguin's painting.

At some point van Gogh expressed
an interest in the drawing and borrowed
or was given it. Gauguin may have in-
scribed the drawing at that time with
the instruction to van Gogh that the eye
should be placed farther from the ridge
of the nose. The first of van Gogh's ver-
sions of *L'arlésienne* was painted at Arles
in 1889; three other painted versions
were completed in 1890 in the asylum
at Saint-Rémy.

FREDERICK CHILDE HASSAM
American, 1859–1935
*Rainy Night,* ca. 1895
Watercolor and gouache over graphite underdrawing
on wove paper, 11¼ × 8¼ in. (285 × 210 mm)
Signed lower left: *Childe Hassam*
Gift of Louise H. Felker and Margery H. Strass in
memory of Rosalie G. Hellman
1978.2.30

Watercolor was a favorite medium of Hassam's from an early age. By the
time he moved to New York in 1889, his watercolors had become the most
advanced and sophisticated aspect of his art. Typical of his preference for
small-scale watercolors, *Rainy Night* exemplifies Hassam's confidence in his
ability to manipulate the medium. He has captured not only the look but
also the damp atmosphere of a rain-drenched New York street.

HENRI DE TOULOUSE-LAUTREC
French, 1864 – 1901
*Au cirque: Cheval pointant,* 1899
Black chalk with orange and yellow crayon additions
on wove paper, 14 × 10 in. (357 × 254 mm)
Inscribed with monogram lower left
Elizabeth Ebert and Arthur W. Barney Fund
1977.2.5

In 1899 Toulouse-Lautrec was committed to a sanitarium with amnesia and
other ailments brought on by alcoholism. When he had recovered some-
what, the artist attempted to convince his doctors that he was well enough
to leave by executing a series of drawings based on his memories of the cir-
cus. This group of thirty-nine drawings ranks among the artist's greatest
accomplishments. *Au cirque: Cheval pointant* is one of the most dramatic
works of the series. Toulouse-Lautrec has employed only subtle touches of
orange and yellow crayon to complement the black chalk that defines this
powerful drawing.

LÉON BAKST
Russian, 1886–1924
*La légende de Joseph: Costume for Potiphar's Wife,* 1914
Graphite and gouache on paper; 19 × 13 in. (483 × 330 mm)
Signed lower right in pencil: *Bakst*
Gift of Mrs. Adolph B. Spreckels
1959.38TD

This is one of fourteen drawings by Léon Bakst in the Theater and Dance
Collection established by Alma de Bretteville Spreckels who, with her
husband Adolph B. Spreckels, founded the California Palace of the Legion
of Honor.

   A brilliant colorist, Bakst was one of the first artists commissioned
by impresario Serge Diaghilev to create costumes and sets for the Ballets
Russes. The sensuous beauty and vivid exoticism of his designs captivated
audiences during the company's first Paris season and greatly influenced
the fashions of their time. This luxurious gown for Potiphar's wife in *La
légende de Joseph* boldly mixes patterns, colors, and touches of gold paint
to suggest the opulent splendor of Potiphar's household, in contrast to the
pastoral life led by Joseph and his family. By selectively exposing portions
of the female figure, Bakst sets up a tension between seen and unseen that
is characteristic of his work and also reflects the seductive nature of the role.

NATALIA GONTCHAROVA
Russian, 1881–1962
*Project for Decor, Act I, "Le coq d'or,"* 1914
Graphite, watercolor, and gouache on illustration board;
19⅜ × 27⅛ in. (492 × 689 mm)
Signed lower right in ink: *N. Gontcharova;*
below this in pencil: *N. Gontcharova*
Gift of Mrs. Adolph B. Spreckels
1959.36TD

Russian folk art was the source of the festive colors, distorted perspective, and stylized floral motif of Natalia Gontcharova's decor for *Le coq d'or.* Her neoprimitivist interpretation emphasizing flat planes of luminous color stunned Parisian audiences; they applauded wildly when the curtain first rose on 21 May 1914.

Gontcharova was commissioned by Serge Diaghilev to design this opera-ballet, based on the narrative poem by Alexander Pushkin, as her first work for the Ballets Russes. Following initial discussions the choreographer Michel Fokine correctly surmised (he recalls in *Against the Stream,* published in Russian in 1962) that Gontcharova would produce "something unexpected, beautiful in color, profoundly national, and at the same time enchanting."

EMIL NOLDE
German, 1867–1956
*Branch of Orchids*
Watercolor on Japan paper,
13¼ × 18½ in. (337 × 470 mm)
Signed lower left: *Nolde*
The Bruno and Sadie Adriani
Collection
1971.10

At his studio home in Seebüll, in the bleak countryside near the German-Danish border, Nolde planted the lush flower garden that would provide him with numerous watercolor subjects. "The blossoming colors of the flowers and the purity of those colors—I love them," he wrote. "I loved the flowers and their fate; shooting up, blooming, radiating, glowing, gladdening, bending, wilting, thrown away, and dying." Nolde used a highly absorbent Japanese paper for the Museums' watercolor. He applied watercolor to the moistened paper, allowing the pigments to flow into each other to create transparent color effects. This, in turn, conveyed spontaneity to his subject.

RICHARD DIEBENKORN
American, b. 1922
*Seated Woman,* 1965
Gouache and ballpoint pen on
wove paper, 12⅞ × 16⅞ in.
(315 × 430 mm)
Signed upper left: *RD 65*
Bequest of Beatrice Judd Ryan
1967.16

Diebenkorn created this drawing a year after being artist-in-residence at Stanford University, where he executed many semi-abstract drawings of the female figure. His melding of the figure with the abstract in color, line, form, space, and composition reflects his love for Matisse's art. This drawing also represents Diebenkorn's significant contribution to the revival of figurative painting on the West Coast.

GEORGIA O'KEEFFE
American, 1887–1986
*The City (New York Rooftops)*, ca. 1925–1930
Charcoal on laid paper, 24½ × 18¾ in. (623 × 478 mm)
Gift of Mrs. Charlotte S. Mack
1961.48.1

In 1924 O'Keeffe and her husband, the photographer Alfred Stieglitz, moved
into their apartment on the thirtieth floor of the Shelton, overlooking Lex-
ington Avenue. From her studio window O'Keeffe painted and drew many
scenes of New York City. This highly controlled and focused composition,
executed in charcoal for a velvety surface, illustrates the dynamism of the
city by light and dark contrast and the straightforward rendering of formal,
flat, and abstract shapes.

ALBRECHT DÜRER
German, 1471–1528
*Knight, Death, and Devil*, 1513
Engraving, M.74; 9⅞ × 7½ in.
(250 × 190 mm)
Bequest of Ruth Haas Lilienthal
1985.1.85

Albrecht Dürer, the great German artist of the northern Renaissance, created a large number of woodcuts, engravings, and etchings. *Knight, Death, and Devil* is the first of his master engravings. (The other two, *Saint Jerome in His Study* and *Melancolia I* were executed a year later.) Dürer's Knight, inspired by Desiderius Erasmus's *The Handbook of the Christian Soldier* (1505), personifies Christian faith as he rides confidently through a haunted ravine, undismayed by Death and a Devil. Dürer's inspiration for the proportions of the horse derived from Leonardo da Vinci's drawings for the Sforza and Trivulzio equestrian monuments. Dürer used the same pose as Leonardo for the horse and the same system of geometry to illustrate ideal proportion.

REMBRANDT HARMENSZ. VAN RIJN
Dutch, 1606–1669
*Christ Crucified between Two Thieves:
The Three Crosses*, 1653
Etching, drypoint, and burin,
Holl.78 iv/v; 15⅛ × 17⅞ in.
(385 × 450 mm)
Achenbach Foundation for
Graphic Arts purchase
1964.142.40

Religious themes were of interest to Rembrandt throughout his prolific and successful career as a painter and print-maker. This illustration of Christ's last hours on the cross is considered one of Rembrandt's most important prints because of the innovative changes he made between the third and fourth states. The divided focus of the third state is clarified in the fourth by additional crosshatching with the etcher's needle to create a more velvety and absorbent black. By creating such a distinct contrast between light and dark, Rembrandt evoked the implication of life and death and the suggestion of new life.

RICHARD EARLOM
English, 1743–1822
*The Drop Forge,* 1773
After a painting by Joseph Wright of Derby, 1734–1797
Mezzotint, W. i/ii; 18⅞ × 23½ (480 × 596 mm)
Inscribed in the plate: *Jo. Wright Pinx. 1772 / Rd. Earlom
Sc. / J. Boydell Excudit / Published Jan*. *1, 1773*
Joseph M. Bransten Fund and Achenbach Foundation for
Graphic Arts Purchase
1982.1.78

Mezzotint is a form of tonal printmaking developed in the seventeenth
century in which the whole plate is engraved and the image then composed
by burnishing out the highlights. By the end of the eighteenth century, espe-
cially in England, the mezzotint had become a highly sophisticated and very
popular medium.

One of the most gifted mezzotint artists of the era was Richard Earlom,
whose fancy-piece mezzotint technique matched the skills of the painters
who employed him. Joseph Wright of Derby's brilliantly composed and
lighted paintings of contemporary scientific and industrial experiments
treated this subject matter with the same important attention that religious
scenes received a century earlier. Earlom's interpretation of Wright's paint-
ing is a tour de force whose virtuosity still startles after two hundred years.

MAURICE PRENDERGAST
American, 1859–1924
*After the Review,* 1895
Monotype, 7⅞ × 5¾ in. (255 × 200 mm image),
14⁹⁄₁₆ × 11 in. (370 × 280 mm sheet)
Signed in the image in reverse: *Prendergast 1895*
Walter H. and Phyllis J. Shorenstein Foundation Fund
and gift of Mrs. Allie M. Sparks
1986.1.40

The invention of the monotype as a form of printmaking is generally
credited to the Italian baroque artist Giovanni Benedetto Castiglione (1616–
1670). Maurice Brazil Prendergast was the most distinguished American
practitioner of the medium, and made about two hundred monotypes in his
career. In a letter to a student he described his technique: "Paint on copper
in oils, wiping parts to be white. When picture suits you, place on it Japanese
paper and either press in a press or rub with a spoon til it pleases you.
Sometimes the second or third plate [*sic*] is the best." *After the Review* is a
fine example of how Prendergast mastered this subtle medium, using delicate
colors and draftsmanship to evoke the genteel era he wished to celebrate.
There is another version of this monotype in a private collection.

LUDWIG HOHLWEIN
German, 1874–1949
*Wilhelm Mozer,* 1909
Color lithograph poster, 46⅝ × 34 in. (1185 × 863 mm)
Achenbach Foundation for Graphic Arts purchase
1983.1.1

In addition to fine prints, the Achenbach Foundation has a broad collection of American and European posters of the nineteenth and twentieth centuries. Ludwig Hohlwein is the finest and most prolific German poster artist of the twentieth century. His posters are distinguished by the simplified rendering of his subject in bold color harmonies. The typography in his posters is carefully positioned but usually subservient to the image that carries the message. In this poster the luxurious array of food compels interest in the name and address of this famous Munich delicatessen.

VASSILY KANDINSKY
Russian, 1866–1944
*Orange (Composition with Chessboard),* 1923
Color lithograph, R.180; 15⅞ × 15¼ in. (405 × 382 mm)
Signed lower right: *Kandinsky,* and numbered lower left: *No. 32/50*
Gift of Mrs. J. Wolf in memory of Miss Rachel Abel
1942.17

Kandinsky, universally regarded as one of the pioneers of abstract art,
elaborated further on his geometrical and, for the most part, wholly non-
representational compositions during the years 1922–1933 when he taught
at the Bauhaus. The circle in *Orange* represents Kandinsky's favorite picto-
rial motif during this period, which replaced the horseman from his Blue
Rider period.

JASPER JOHNS
American, b. 1930
*Two Maps, I,* 1966
Lithograph printed in gray on black Fabriano paper,
33½ × 26⅝ in. (850 × 678 mm)
Signed lower right: *J. Johns '65 – '66,* and numbered lower left: *I 23/30*
Achenbach Foundation for Graphic Arts purchase
1966.80.74

Pop Art, an American movement in the late 1950s, employed commercial
techniques to depict objects from everyday life or popular images. In the mid-
sixties Johns used the familiar American motif of the map, illustrating two
of them in a flat, yet painterly manner that is imitated in the lithographic
medium. He has drawn the maps with such subtlety that their shapes can
be seen either as description or as surface design. This lithograph is an
important part of Johns's total creative output as a printmaker. It is one
of the many prints he created at Tatyana Grosman's Universal Limited Art
Editions, where he began his work in lithography.

UTAGAWA KUNIMASA
Japanese, 1773–1810
*Bust Portrait of Nakamura Nakazo II as Matsuomaru*, 1796
Color woodcut (right panel of an ōban triptych),
15⅛ × 10¼ in. (385 × 260 mm)
Achenbach Foundation for Graphic Arts purchase
1970.25.41

The drama of divided loyalties is the subject of many Kabuki plays and
Japanese prints. In this scene, Matsuomaru guards his master's carriage
as his two younger brothers, who serve a rival lord, attack it. Kunimasa's
close-up portrait conveys the powerful presence of the young actor Naka-
mura Nakazo II in this tense scene. This was one of Nakazo's last perform-
ances. He died at the end of 1796. The print is part of a rare series that may
have been privately published; special effects like the colored outline, hand-
painted eyes, and lacquer on the cap do not appear on regular commercial
prints of the 1790s.

TSUKIOKA YOSHITOSHI
Japanese, 1839–1892
*Fujiwara no Yasumasa Playing the Flute by Moonlight,* 1883
Color woodcut ōban triptych, 14 × 28⅛ in. (355 × 715 mm)
Achenbach Foundation for Graphic Arts purchase
1982.1.32

Yasusuke, a bandit in medieval Japan, swore that he would kill the next
passerby to obtain warm clothing that he needed to survive the coming
winter. Soon he saw an unprotected nobleman walking across the moor,
playing his flute in the moonlight. When the moment came to draw his
sword and strike, the bandit was transfixed by the beauty of the music.

Yoshitoshi showed a painting of this subject in a national exhibition in
1882. The painting caused no stir, but the next spring this print caused a
sensation in Tokyo. It became so popular that two leading Kabuki actors
performed it as a living tableau in a dance play. This is the second state of
the print, with the name of the printer beside the artist's signature. In the
third and last state, the color blocks for the sky were recarved.

ANONYMOUS
Indian, Mughal, ca. 1625–1650
*Two Royal Antelopes*
Ink and gouache on paper, 6⅝ × 8¼ in. (160 × 210 mm)
Bequest of Ruth Haas Lilienthal
1975.2.12

The restrained, delicate hand of the painter has rendered these antelopes
with the unaffectedly direct and charming naturalism that was much prized
at the imperial Mughal courts of Jahangir and Shah Jahan. The graceful
animals are carefully depicted in every detail down to the male's exquisitely
worked tether, while the peaceful game park meadow is barely suggested.

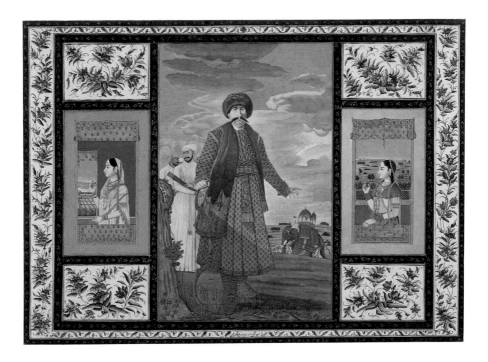

ANONYMOUS
Indian, late Mughal, Delhi or Lucknow School
*Lady Eyre Coote Album: Portrait of Nawab Shuja-ud-Daula of Oudh,* ca. 1780
After a painting by Tilly Kettle, English, 1735–1786
Ink and gouache on paper, 13½ × 12⅝ in. (342 × 320 mm main image),
17¾ × 24 in. (457 × 610 mm sheet)
Gift of Mr. and Mrs. John D. MacDonald and Achenbach Foundation
for Graphic Arts purchase
1982.2.70.1

This dramatic portrait of the ruler of Oudh was copied by an Indian painter,
possibly Mir Chand of Lucknow, from one of the portraits painted by Tilly
Kettle in Faizabad in 1772. The small paintings on either side are presum-
ably idealized portraits of two of the Nawab's many wives.

The inscription on the album to which this painting belongs identifies it
as a gift to Lady Eyre Coote from Colonel Antoine Louis Henry Polier. Lady
Coote's husband commanded armies of the British East India Company,
while the Swiss Colonel Polier served first the Company and later the
Nawab of Oudh. The album cover, ten paintings, and seven calligraphy
pages are in the Museums' collection. The other known pages from this
album are also in American museums (one calligraphy sheet in San Diego
and one painting and two calligraphy pages at Harvard).

ANONYMOUS DAGUERREOTYPIST
American, 19th century
*Mother and Child*
One-sixth-plate daguerreotype,
$2^{15}/16 \times 2^{7}/16$ (75 × 62 mm)
Gift of Sean H. Thackrey
1986.3.15

The daguerreotype was the first widely
seen form of photography. The compli-
cated and time-consuming process pro-
duced an image, often of startling clarity,
on a polished silver-coated piece of cop-
per. Each daguerreotype was unique as
there was no negative from which copies
could be made.

The daguerrean era was unfortunately
brief—only from 1840 until around 1858.
It was ended, not surprisingly, by eco-
nomics and advanced technology.
Although cheaper, more sophisticated
forms of photography supplanted the
daguerreotype, they could not duplicate
the inherent beauty of photographs like
this tender portrait of a mother and child.

In 1858 an anonymous author in the
photographic manual *Sunlight Sketches*
wrote mournfully, "O sad fate of the
beautiful daguerreotype! I would to
heaven I could forget it. But it lingers
in my soul like fond remembrance of
a dear departed friend."

OSCAR GUSTAVE REJLANDER
Swedish, 1813–1875
*Grief*, 1864
Albumen print from glass collodion
negative, $7^{5}/8 \times 5$ in. (194 × 140 mm)
Initialed and dated in the negative:
*OGR / 1864*
Gift of John H. Rubel
1985.100.2

Rejlander was a Swedish artist who
settled in Wolverhampton, England.
Originally a portrait painter and copyist
of old masters, he turned to photography
in 1855. Today he is primarily remem-
bered for the use of combination printing,
which employs more than one negative
to print a large photograph. Rejlander
also attempted to advance the aesthetic
side of photography by composing elab-
orate tableaux of posed models, based
on allegorical themes. The style of these
photographs resembled many paintings

of the time. In this photograph, however,
the strong theatrical element is balanced
by the simplicity of the pose.

# TEXTILES

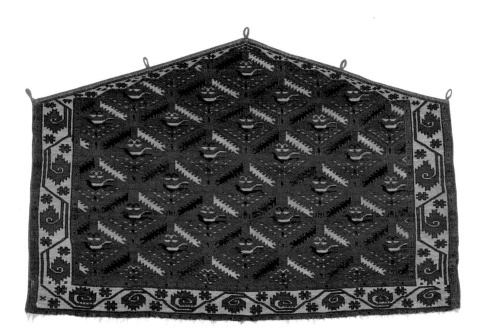

*ASMALYK* (CAMEL TRAPPING)
Western Turkestan, Turkmen, Tekke, 18th century
Extra-weft cut-pile wrapping (asymmetrical—open on the right—"knot"),
wool; 3 ft. 10 in. × 2 ft. 6½ in. (116.8 × 77.5 cm)
H. McCoy Jones Collection
L1980.32.27

This pentagonal *asmalyk* was made by a Tekke tribe to decorate the bride's
camel during the wedding procession. It is one of fifteen known Tekke
"bird" *asmalyks*, its field pattern probably derived from the ancient birds
and tree-of-life design. Its lustrous wool, rich red colors, clarity of depiction,
and formal relationships typify Turkmen weaving at its sumptuous best. In
a collection of more than 250 Turkmen rugs, this piece stands out as one of
the truly great examples. Its former owner acquired it in Tehran in 1931.

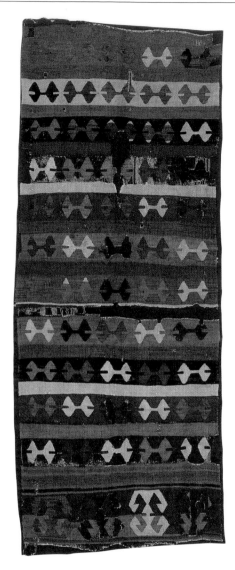

KILIM FRAGMENT
Central Anatolia, 18th century
Slit-tapestry weave, wool; 2 ft. 7 in. × 6 ft. × 9½ in. (78.7 × 207.9 cm)
Museum purchase, gift of The Fine Arts Museums Volunteer Council
1984.61

Flat-woven rugs, in general, were not commodities, and tended to retain
their traditional patterns and colors longer than did pile rugs. The motifs
on this kilim appear to be very early; it is possible that they date back to
neolithic times. Subtle use of color and a strong interplay between negative
and positive forms are characteristic of the art of early Anatolian weavings.

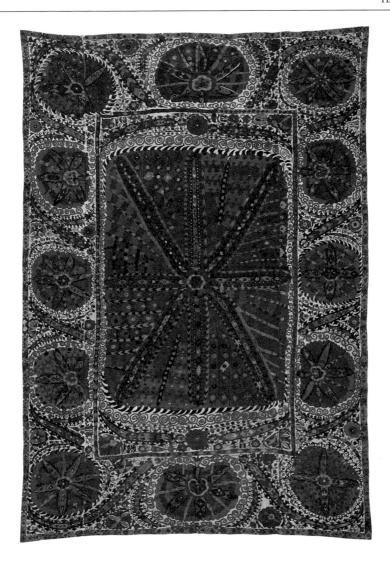

*SUZANI*
Southwest Uzbekistan, Bokhara, 18th/19th century
Embroidery, silk on cotton; 6 ft. 5 in. × 9 ft. 4 in. (1.95 × 2.84 m)
Caroline and H. McCoy Jones Collection
1985.89.6

*Suzanis*, embroideries made as dowry by settled peoples in the regions
of Samarkand, Bokhara, and Tashkent, represent the town art of Central
Asia at its most creative. This Bokhara *suzani*, the most outstanding of the
thirteen known large-medallion examples, is an excellent case in point. Its
impressive range of colors, the skillful use of different embroidery stitches,
and its perfect formal correspondences result in a haunting rhythmic
balance.

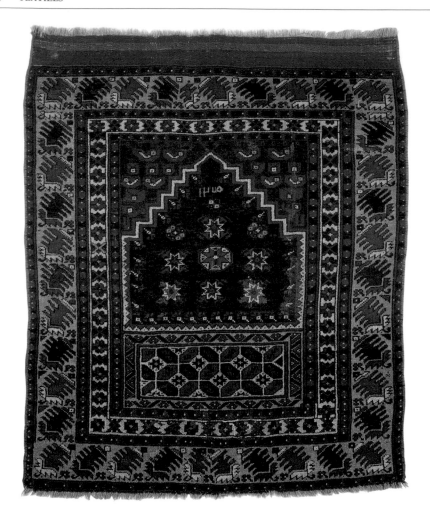

"PRAYER" RUG
Western Anatolia, Yagcibedir, early 19th century
Extra-weft cut-pile wrapping (symmetrical "knot"), wool;
3 ft. 1 in. × 3 ft. 8 in. (94 × 111.8 cm)
H. McCoy Jones Collection
1984.91.3

The inscribed date indicates that this so-called prayer rug was made in the
early part of the nineteenth century, even though the last digit is obscured
by repairs. Exactly why rugs were dated and which ones were actually used
for prayer awaits clarification. It is quite possible that dates first appeared
on rugs to note the time of death or birth of a member of a family. The
small size of this rug, its style of arch, and its date suggest that it may have
been given to a mosque for such a commemorative purpose. It is a classic
example of the "prayer" rugs from this locale.

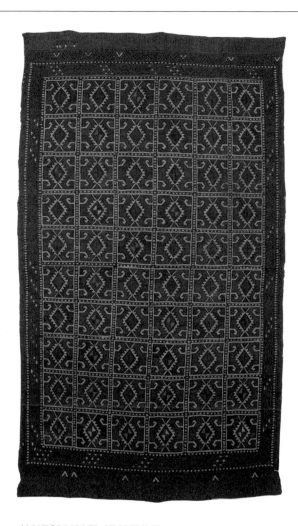

ANATOLIAN FLAT-WEAVE
Western/Central Anatolia, early 19th century
Reverse-extra-weft wrapping, weft-float brocading, wool, cotton;
2 ft. 9 in. × 3 ft. 1 in. (83.8 × 94 cm)
H. McCoy Jones Collection
L1980.32.89

This Anatolian flat-weave is as tantalizing as it is charming. As dates rarely
appear on this type of flat-weave, it is not clear why the piece is dated
(1816 – 1817). In addition, the structure (reverse-weft wrapping) is relatively
uncommon on Turkish flat-weaves. Other technical variances suggest that
two weavers, one situated at the back of the loom, wove this small piece.
There are no obvious explanations for this arrangement. Furthermore, the
limited palette and juxtaposition of forms and colors are so typical of Turk-
men weavings from Central Asia that it is puzzling that no other similar
Anatolian or even Central Asian examples have survived.

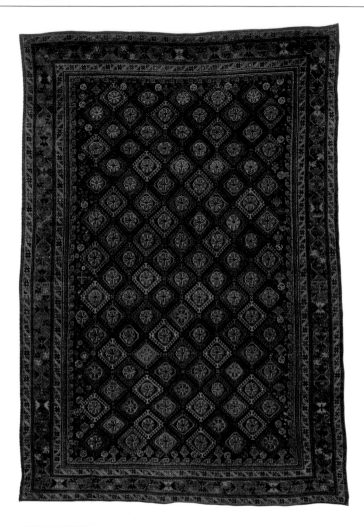

TRIBAL RUG
Afghanistan, Timur[?], 19th century
Extra-weft cut-pile wrapping (asymmetrical—open on the left—"knot"),
wool; 8 ft. × 11 ft. 10 in. (2.43 × 3.60 m)
Caroline and H. McCoy Jones Collection
L84.64.1

This unique carpet was formerly part of the prestigious Hartley Clark
Collection, which was published in 1922. Clark's attribution—Adraskand
valley—awaits proof. At this time it is not clear exactly where in Afghanistan
and by what tribal confederation it was made. Overall repeat patterns are
common in tribal rugs. What sets this piece apart are its luminous colors
and their unpredictable placement. Carpets have often been compared to
stained-glass windows. This is an ideal candidate because the variation
in color suggests light emanating from behind the carpet.

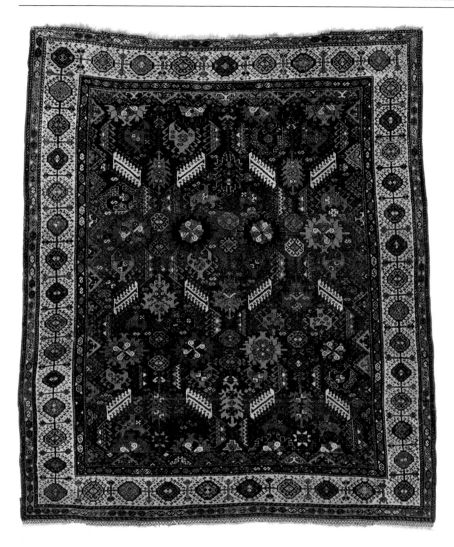

TRIBAL RUG
Southern Persia, Fars province, Khamseh, 19th century
Extra-weft cut-pile wrapping (asymmetrical—open on the left—"knot"),
wool; 5 ft. 4 in. × 6 ft. 8 in. (1.62 × 2.03 m)
H. McCoy Jones Collection
L1980.32.78

This is a classical example of carpets made by the Khamseh confederation
of five tribes, which was formed in 1862. The arrangement and rendition of
many of the motifs suggest that they are elaborate derivations of the ancient
animals and tree-of-life pattern. However, when interpreting designs on
Oriental carpets one should remember Paul Klee's statement, "Art does
not reproduce the visible but makes visible."

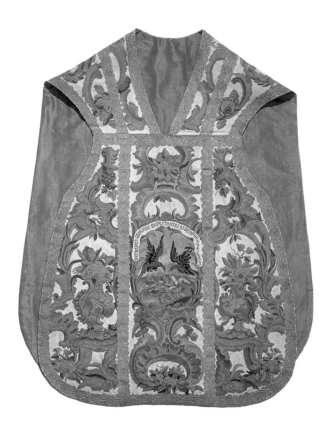

CHASUBLE
Poland, Cracow, 1747–1758
Woven at the workshop of F. Glaize for
Bishop Andreas Stanislas K. Zaluski
Off-white linen warp; polychrome wool,
silk, gold, and silver wefts; tapestry weave
Gift of Archer M. Huntington
1934.3.256

The chasuble's flowers and pleasing colors belie its subject: the martyrdom
of Saint Stanislaus, bishop of Cracow in the eleventh century. The iconog-
raphy seems based on the earliest version of the saint's legend. The center
front cartouche portrays the saint being attacked; the back cartouche depicts
eagles seeking to unite the dismembered portions of the saint's body. The
name of Bishop Zaluski is woven into the border of this chasuble. In 1753 he
celebrated the five-hundredth anniversary of Saint Stanislaus's canonization.

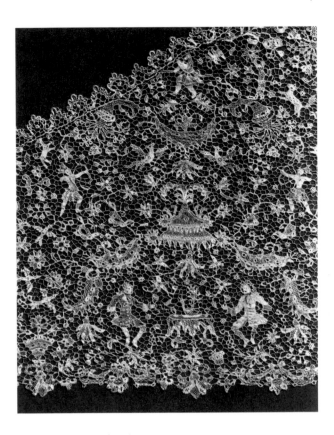

LACE COLLAR (detail)
France, ca. 1689–1720
*Point de France*
Gift of Mrs. D. L. Wemple
77.24.13

The pattern of this pictorial needle lace,
composed of two mirrored halves, shows
two fashionably dressed men drinking
wine beneath a canopy, surrounded by
Indians, rabbits, squirrels, birds, plants,
and flowers. The lace is much lighter
stylistically than the heavy baroque
laces popular in the seventeenth century,
but it lacks the mesh ground characteris-
tic of eighteenth-century laces.

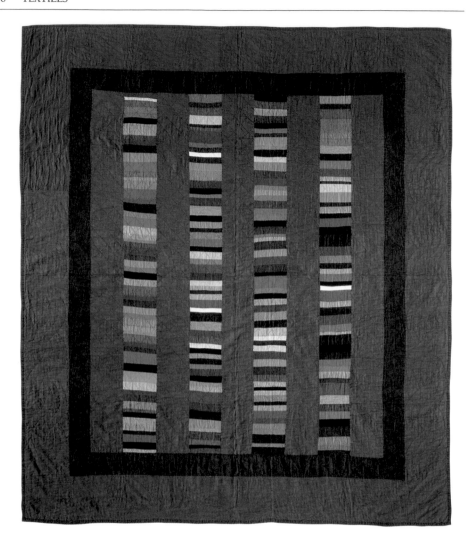

QUILT
American, Amish, ca. 1925–1940
Pieced cottons, 72½ in. × 62 in. (1.84 × 1.57 m)
Anonymous gift
1984.73

This "Chinese Coins" pattern is a favorite among the Amish of the Midwest
and seems to be a variation on the plainer bar motif beloved of the Lancaster
County Amish. The source of the pattern's unusual name remains a mystery;
perhaps the many strips of fabric comprising the bars were compared to the
beads on an abacus. Amish traditions discourage the use of patterned fabrics
and elaborate quilting. Quilts like this one derive their power from their
bold but simple designs, deeply saturated colors, and fine workmanship.

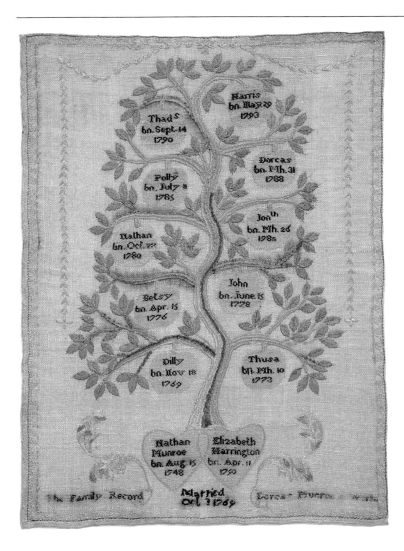

SAMPLER
American, ca. 1800
Polychrome silk on linen,
16¾ × 12¼ in. (43 × 31.5 cm)
Gift of Mrs. Jessie Allard Kline
78.19.1

This sampler illustrates the Munroe family tree, appealingly worked by
Dorcas Munroe. Family record samplers, which can also be viewed as valu-
able social documents, were popular in America throughout the eighteenth
and well into the nineteenth centuries. The tree motif seen here seems to
appear specifically in samplers made in the greater Boston area during the
first quarter of the nineteenth century.

WOMAN'S DRESS
French, ca. 1980
Yves Saint Laurent
Silk velvet and taffeta
The Eleanor Christenson de Guigné
Collection (Mrs. Christian de Guigné III)
Gift of Ronna and Eric Hoffman
1985.44.42 a–b

Yves Saint Laurent, one of France's lead-
ing postwar couturiers, joined Christian

Dior in 1954 and left to open his own
couture house in 1961. This evening
ensemble is one example of the Museums'
considerable holdings of his day and
evening wear. The gown's glowing, unre-
lieved midnight blue, the constant play
of light and shade between the velvet
and taffeta, and the contrast of the plain
thigh-length bodice against the flounced
and gathered skirt make the dress
simultaneously stark and luxurious.

MAN'S SUIT
English, ca. 1780–1785
Silk brocade, polychrome silk embroidery
Museum purchase, Art Trust Fund
1982.4 a–b

This suit of rich aubergine silk brocade embellished with flowers embroidered in shaded silks represents late eighteenth-century men's formal dress at its best. It may originally have had a matching waistcoat, now lost, and was probably intended for wear at court. Men's clothing became increasingly plain as the eighteenth century drew to a close; this sort of lavish surface decoration would have been reserved for the most formal of suits.

FAN
English, ca. 1750
Gouache on vellum, pierced ivory sticks and guards
Gift of Susanne King Morrison in memory of Elizabeth Brant King
1980.66

The mask fan, with its cutout eyes, was an accessory that would have
allowed a woman to conceal her face at will. There are only six such fans
known in public and private collections, all sharing the central oval mask
but with differing side scenes. Here couples amuse themselves in town and
country. The townscape on the left, showing a woman in her sedan chair,
also appears on a fan now in the Kremlin.

*RABBIT-HUNTING WITH FERRETS*
Franco-Flemish, probably Tournai, 1460–1470
Warp: undyed wool, 6 per cm; weft: dyed wool and silk;
10 ft. × 11 ft. 11 in. (3.05 × 3.63 m)
M. H. de Young Endowment Fund
39.4.1

In the lower left corner of this tapestry a peasant releases a ferret into a
rabbit burrow. The rest of the tapestry tells the story of the hunt, as men
are helped by women to capture the escaping rabbits in nets, then dispatch
them. The seriousness of purpose shown by these hunters at work is dimin-
ished by the caricatural quality of their faces and the coarse simplicity of
their dress.

   Although peasants are not commonly the subjects of tapestries, inven-
tories prove that these works were once popular. Two other panels from
the same set of cartoons, showing other stages of the hunt, survive in the
Burrell collection in Glasgow and in the Louvre.

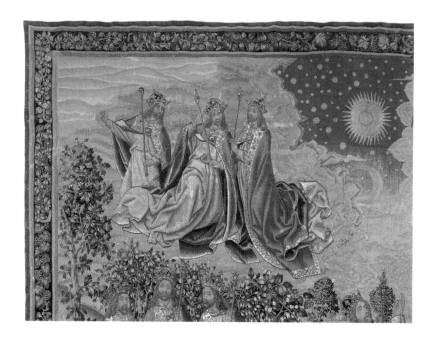

*THE CREATION AND THE FALL OF MAN* (detail)
From *The Redemption of Man* series, panel 1
Flemish, Brussels, 1510–1515
Warp: undyed wool, 5–6 per cm; weft: dyed wool with silk accents;
13 ft. 8 in. × 26 ft. 8 in. (4.17 × 8.13 m)
Gift of the William Randolph Hearst Foundation
54.14.1

The first panel in this series illustrates the six days of Creation as told in
Genesis. The Trinity is enthroned in Paradise at upper center, surrounded by
angels and flanked by Mercy and Justice. Scenes of the Creation are depicted
in a semicircle, beginning in the upper left corner of the tapestry, illustrated
here. First light and firmament, then land and the heavens appear; birds
and fishes take form and are blessed, followed by the animals and man. The
story is completed by the two episodes of man's fall from grace. This is one
of three surviving weavings of this exceptional design.

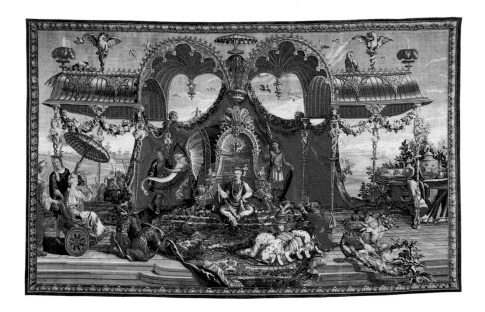

*THE AUDIENCE OF THE EMPEROR*
From *The Story of the Emperor of China* tapestry series
French, Beauvais, before 1732
Designed by Guy Louis de Vernansal, Belin de Fontenay,
and, probably, Jean Baptiste Monnoyer
Probably woven under the direction of Mérou
Warp: undyed wool, 8.5 per cm; weft: dyed wool and silk;
10 ft. 5 in. × 16 ft. 6 in. (3.18 m. × 5.03 m)
Gift of the Roscoe and Margaret Oakes Foundation
59.49.1

This scene, a wonderful example of the craze for chinoiserie spurred
by contemporary illustrated accounts of Cathay, was probably inspired
by a Jesuit mission to the Manchu emperor's court in 1688. The exotically
dressed emperor holds court in the open air, seated on a rich Oriental rug.
To his right, four visitors kowtow to him; to his left, a foreign woman sits in
a baroque rickshaw drawn by two black men. The arched loggia bedecked
with flowers, feathers, and griffins, the elephant emerging from the back of
the dais, and the fanciful costumes of the visitors and guards contribute to
the tapestry's exotic air.

# THE FINE ARTS MUSEUMS OF SAN FRANCISCO PUBLICATIONS ON THE COLLECTIONS

The Fine Arts Museums of San Francisco initiated a program of publishing the collections even during the first stages of the merger of the two museums. The following list includes prices for books still in print, and they may be ordered by writing The Museum Society Bookshops, M. H. de Young Memorial Museum, Golden Gate Park, San Francisco, California 94118.

## ART OF AFRICA, OCEANIA, AND THE AMERICAS

*Traditional Art of Africa, Oceania, and the Americas,* Jane Powell Dwyer and Edward Bridgman Dwyer, 1973. 176 pp.

## SCULPTURE

*Rodin's Sculpture: A Critical Study of the Spreckels Collection,* Jacques de Caso and Patricia B. Sanders, 1977. 360 pp.

*American Sculpture: The Collection of The Fine Arts Museums of San Francisco,* Donald L. Stover, 1982. 96 pp., paper $11.95

## PAINTINGS

*Three Centuries of American Painting,* F. Lanier Graham, 1971. 112 pp.

*American Art: An Exhibition from the Collection of Mr. and Mrs. John D. Rockefeller 3rd,* E. P. Richardson, 1976. 256 pp.

*French Paintings 1500–1825. The Fine Arts Museums of San Francisco,* Pierre Rosenberg and Marion C. Stewart, to be published December 1987. 400 pp., price not set.

## PRINTS AND DRAWINGS

*Four Centuries of French Drawings in The Fine Arts Museums of San Francisco,* Phyllis Hattis, 1977. 360 pp., paper $15.00, cloth $20.00

*Russian Theater and Costume Designs,* introduction by John F Bowlt, catalogue by Nikita D. Lobanov, Nina Lobanov, and Aimée Troyen, 1979. 64 pp., paper $1.99

*Master Drawings from the Achenbach Foundation for Graphic Arts,* Robert Flynn Johnson and Joseph R. Goldyne, 1985. 232 pp., paper $19.95, deluxe edition $225.00

## TEXTILES

*Five Centuries of Tapestry in The Fine Arts Museums of San Francisco,* Anna G. Bennett, 1976. 254 pp.

*Acts of the Tapestry Symposium: November 1976,* edited by Anna G. Bennett, 1977. 226 pp., paper $15.00

*Fans in Fashion,* Anna G. Bennett with Ruth Berson, 1981. 129 pp., paper $15.00

*Tent & Town: Rugs and Embroideries from Central Asia. The H. McCoy Jones Collection,* Cathryn M. Cootner, 1982. 16 pp., paper $2.95